HUMOR'S EDGE

CARTOONS BY ANN TELNAES

Emma,
To my favorite Democrat!
Love and Happy Birthday

Laura

Sept. 2004
Chas. SC

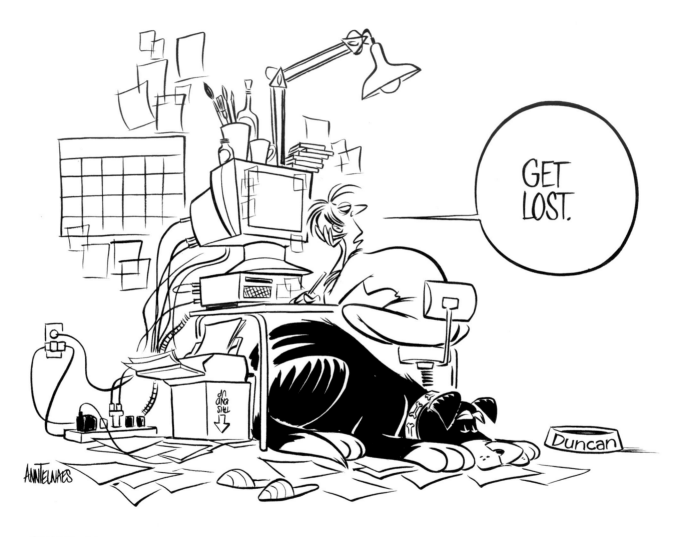

GET LOST, 1/4/00
© Ann Telnaes

Self-portrait: Ann in her natural environment.

HUMOR'S EDGE
CARTOONS BY ANN TELNAES

Ann Telnaes Interviewed by Harry Katz
Introduction by Ben Sargent

Pomegranate

SAN FRANCISCO

IN ASSOCIATION WITH THE LIBRARY OF CONGRESS

Published by Pomegranate Communications, Inc.
Box 808022, Petaluma CA 94975
800 227 1428; www.pomegranate.com

Pomegranate Europe Ltd.
Unit 1, Heathcote Business Centre
Hurlbutt Road, Warwick
Warwickshire CV34 6TD, U.K.; [+44] 0 1926 430111

Library of Congress
Director of Publishing: Ralph Eubanks
Editor: Linda Barrett Osborne
Research, captions: Anjelina Keating, Linda Barrett Osborne, Martha H. Kennedy

Library of Congress Cataloging-in-Publication Data

Telnaes, Ann, 1960
 Humor's edge: cartoons by Ann Telnaes / Ann Telnaes interviewed by Harry Katz;
introduction by Ben Sargent.
 p. cm.
 Includes index.
 ISBN 0-7649-2868-6 (alk. paper)
 1. United States—Politics and government-2001—Caricatures and cartoons. 2. United
States—Politics and government—1993-2001—Caricatures and cartoons. 3. American wit
and humor, Pictorial. 4. Telnaes, Ann. 1960—Interviews. 5. Cartoonists—United
States-Interviews. I. Katz, Harry L. II. Title.
E902.T45 2004
741.5'973—dc22 2004045174

Pomegranate Catalog No. A745

Design by Lynn Bell, Monroe Street Studios, Santa Rosa, California

Cover image: "We interrupt our regularly scheduled programming to bring you reality,"
9/13/01; LC-DIG-ppmsca-01968. Courtesy of Tribune Media Services.

Printed in China

13 12 11 10 9 8 7 6 5 4 10 9 8 7 6 5 4 3 2 1

To D & D

CONTENTS

ACKNOWLEDGMENTS

The Library of Congress wishes to thank the many staff members who made this book possible. Linda Osborne of the Publishing Office focused her editorial skills, unwavering energy and enthusiasm, and generous measures of time to shaping and perfecting the book. Anjelina Keating was an outstanding researcher and wrote many of the perceptive and engaging captions. Ralph Eubanks contributed critical support and expertise to the entire project.

Jeremy Adamson, Chief of the Prints and Photographs Division, generously gave his curatorial opinions and welcome administrative support to both the book and the exhibition. Sara Duke, Associate Curator of Popular and Applied Graphic Art, provided valuable curatorial support and technical advice. Cheryl McCullers, Curatorial Assistant, was a valuable source of much appreciated technical support. Thanks to Helena Zinkham, Brett Carnell, and Cary McStay for managing the care and housing of the original drawings. Mary Ison and Phil Michel greatly facilitated the scanning of the drawings—their aid is gratefully acknowledged. For technical assistance in scanning the drawings, we extend special thanks to members of the Library's scan lab staff, including Domenico Sergi, Ronnie Hawkins, Christopher J. Pohlhaus, and Jade Curtis. For recording the interview with Ann Telnaes, we thank Michael E. Turpin and Michael McDonald of the Recording Lab of the Motion Picture, Broadcasting and Recorded Sound Division.

This book was developed in conjunction with an exhibit of Telnaes' work at the Library of Congress in June/July 2004. Grateful thanks to Irene Chambers, Chief of the Interpretive Programs Office, and Martha Hopkins, Director of the Ann Telnaes exhibit, for their support and invaluable aid in choosing images.

To Ben Sargent, Joel Pett, and Brian Gable, many thanks for their appreciative, insightful comments about Telnaes' work. On a personal and professional level, Ann Telnaes' dedication to her courageous work and her generosity, modesty, and humor have made the entire process of working on the book and the exhibition inspiring and delightful.

Our special thanks also to publisher Katie Burke and to managing editor Eva Strock at Pomegranate, and to designer Lynn Bell, for their creativity, humor, and grace under pressure.

Harry Katz wishes to acknowledge the exemplary, insightful contributions to this book of Martha Kennedy, writer, curator, colleague, and friend.

Ann Telnaes would like to thank the Library of Congress, especially Harry Katz, for his confidence in my work and his certainty (despite my skepticism) that everything would get done for this book and the exhibit; Ralph Eubanks, for his professionalism and willingness to listen to a creator explain her creations; Martha Kennedy, for all her hard work and her pleasant demeanor—no matter what difficulties arose, Martha was always a pleasure to work with. Thanks also to my editor, Linda Osborne, for her talent and wonderful humor throughout this project. Linda's hard work and belief in my work are much appreciated.

Many thanks to Tribune Media Services, King Features, and Women's eNews for their generous permission to reprint the images in this book, as well as to Sara Thaves for her advice and her perspective. Thanks also to Steve Sack and his courageous editorial page editor, Susan Albright, and deputy editor Jim Boyd of the *Minneapolis Star Tribune* for all their help and use of the letters and op-ed column.

A very special thanks to my husband, David, for his patience with my endless deadlines and "writer's block" frustrations, and for his unwavering support of my work.

There's really not all that much to Ann Telnaes—not physically, anyway. Dripping wet, she probably weighs less than her big Swiss mountain dog, Duncan. That's one reason her cartoon originals are a bit of a surprise at first glimpse. They're bigger than most anyone else's, typically a good two feet wide—a case, really, of a woman who wears a size 2-petite working over the cartoon equivalent of the Sistine Ceiling.

Talk about working from the shoulder; while most cartoonists wield a brush or pen from the wrist, Ann must be working from the waist to cover the expanses of her unique, stylish, eye-grabbing drawings. But it's not square footage that makes Ann Telnaes' cartoons huge. No, it's pure impact—that word that's so dulled from overuse with reference to editorial cartoons. But there's no better word to sum up the cumulative effect of the perceptive analysis, bold imagery, trenchant wit, and tireless indignation that make up a Telnaes cartoon. Impact.

And it's that magic ingredient—indignation—that makes the whole combination work, day after day, story after story, issue after issue. It's said that Ann's political cartooning career was born from her outrage over the Chinese government's brutal suppression of the 1991 pro-democracy demonstrations in Tiananmen Square, and nurtured by her revulsion at the treatment of Anita Hill during the Senate confirmation of Supreme Court Justice Clarence Thomas. Whatever it was, after more than a decade of daily cartooning, national syndication, the Pulitzer, and a crowd of other awards, her outrage is undiluted, and illuminates all her drawings with power, cogency, and moral force.

Ann's message flows over the banks of political categorization. It might be easy to call her proudly liberal, but her indignation is kindled by any variety of injustice, oppression, hypocrisy, or sham, from whatever quarter. While she's deployed much of her best venom against affronts to women's rights and civil liberties, she's had plenty left for the vast array of other corruptions, plots, and idiocies that seem so depressingly endemic in public life. Since there's no message without medium, that brings us back around to those big, elegant drawings. They truly are unique in their grace, simplicity, and power of line, probably a reflection of Ann's early

career as an animator and graphic illustrator. And she's a master of the cartoon virtue called "economy of drawing"—every single element in a Telnaes cartoon helps to draw the reader's eye and mind to the message.

Considering this remarkable convergence of powerful drawing, razor-sharp intelligence, and triple-distilled outrage, maybe we misspoke. Ann Telnaes is huge.

—Ben Sargent, Pulitzer Prize–winning editorial cartoonist
Austin American-Statesman

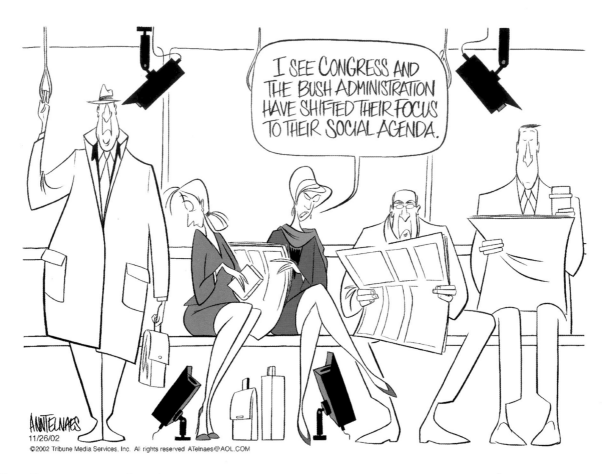

"I SEE CONGRESS AND THE BUSH ADMINISTRATION HAVE SHIFTED THEIR FOCUS TO THEIR SOCIAL AGENDA," 11/26/02
Courtesy of Tribune Media Services

Congressional elections at the end of 2002 resulted in a new Senate majority of Republicans and a larger GOP majority in the House of Representatives. Republican congressional leaders felt moved to state publicly their intentions to promote social policies that reflect conservative views: to discourage abortions, appoint conservative judges, and encourage churches and other groups to help families. Telnaes considers the impact of a conservative agenda on private life through her text and her drawing of invasive surveillance cameras.

ANN TELNAES, CARTOONIST: SINGULAR IN STYLE AND SUBSTANCE

Ann Telnaes creates some of the boldest, hardest hitting editorial cartoons today. The second woman to win the Pulitzer Prize for editorial cartooning in 2001, she is one of the few women who work in the highly competitive arena of editorial cartooning. Unlike most of her peers, who work for specific newspapers, Telnaes works independently and distributes her cartoons through Tribune Media Services. Her singular, streamlined drawings communicate strong views on national and international issues and often pertain to First Amendment, civil, and human rights.

Her cartoons appear regularly in *The Chicago Tribune, The Washington Post*, the *Los Angeles Times*, the *St. Louis Post Dispatch, The New York Times, Newsday, The Baltimore Sun, Austin American-Statesman, USA Today*, and other leading newspapers, where their pointed commentary, wit, and distinctive style appeal to millions of readers. In her drawings, Telnaes consistently upholds the finest tradition of the "ungentlemanly art" of graphic satire, whose practitioners clarify and distill the essence of important, complex issues of the day and convey their opinions or "truths" as they see them. She willingly addresses controversial subjects, her commentary enhanced dramatically by her striking style, which contrasts with the descriptive approaches most of her peers take. Her elegant, linear drawing and clean compositions are easily read and understood. Every carefully chosen detail expresses her sense of humor, her sense of justice—and injustice—and incorporates several levels of meaning. Spare, but far from simple, her cartoons are as thoughtful and as thought provoking as they are pleasing to the eye.

Telnaes won the Pulitzer Prize for a group of cartoons that focused mainly on the problematic presidential election of 2000. As a woman—and as one of the few cartoonists not affiliated with a newspaper during the 81 years the award has been given—she is doubly unusual among Pulitzer winners. Among her honors are Best Cartoonist (Population Institute XVIIth Global Media Awards, 1996); Best Editorial Cartoonist (Sixth Annual Environmental Media Awards, 1996); National Headliner Award for Editorial Cartoons (1997); Maggie Award (Planned

Parenthood, 2002); and Berryman Award for Editorial Cartooning (National Press Foundation, 2003). She has had a solo exhibition, "Pens & Needles: The Editorial Cartoons of Ann Telnaes," at the Newseum in Rosslyn, Virginia (October, 2001–January, 2002), and two exhibitions in France: "International Press Cartoons," Carquefou, January, 2002; and "Un Nouveau Monde?" ("A New World?"), Paris, October, 2002. In addition to her syndicated cartoons, Telnaes independently publishes a weekly "commentoon" in Women's eNews and contributes regularly to *Six Chix,* a comic strip that she and five other women produce collaboratively; it features humorous women's perspectives on everyday life. For a look at Telnaes' work, visit her website at www.AnnTelnaes.com. Telnaes is a member of the Cartoonists Rights Network and has served as Vice President of the Association of American Editorial Cartoonists.

How did Telnaes amass such an impressive record of accomplishment in a profession where less than 5 percent are women, and considering that she did not set out to become an editorial cartoonist? Born in 1960 in Stockholm, Sweden, Telnaes moved to the United States with her family as a child and became a U.S. citizen at the age of 13. Interested in graphic design and illustration, she attended Arizona State University for $2\frac{1}{2}$ years, then pursued more intensive art training at the California Institute of the Arts. She graduated with a Bachelor of Fine Arts in character animation in 1984. Telnaes did freelance work in animation for Disney and smaller studios in Los Angeles, London, and Taiwan, but found the business very assembly line oriented. Seeking more creative outlets, she was hired by Disney Imagineering, where she worked from 1987 to 1993, developing and drawing designs for rides, shows, and characters. She also did freelance assignments in humorous illustration and licensing work for Warner Brothers.

Telnaes made her first political cartoons during her time at Disney. She had always liked political cartoons, but had not, she has said, been very politically aware. Two events proved pivotal in shifting the direction of her career. Working late one night in 1989, she learned about the incidents in Tiananmen Square. She was so angry and shocked that she drew her first political cartoon, although only for her own satisfaction, not for publication. In 1991, upon hearing

the testimony of Anita Hill during the hearings for Clarence Thomas' nomination to the U.S. Supreme Court, she was motivated to produce a series of political cartoons that she sent to newspapers for consideration. From then on, many of her cartoons were published in newspapers such as the *Los Angeles Times, Newsday,* the *Houston Post,* and *Austin American-Statesman.* She began to be published regularly during the 1992 Republican Convention.

Telnaes soon concentrated exclusively on drawing political cartoons, leaving Disney and moving to Washington, D.C., in 1993. In 1994 she tied for first place in a cartoon contest sponsored by *Editorial Humor* magazine (formerly the *Boston Comic News*). Winners' portfolios were sent to syndicates, and on the basis of this and other work, the North American Syndicate (owned by King Features) gave her a contract in their "Best and Wittiest Package." In mid-2000, she moved her editorial cartoons from the North American Syndicate to individual distribution with the Los Angeles Syndicate, which Tribune Media Services subsequently took over.

As a freelancer, in 2001 Telnaes put together her own Pulitzer application package of sixteen drawings, emphasizing her work on the presidential election of 2000. Despite the timely focus of the cartoons, she felt that she had little chance of winning. The Pulitzer Prize committee judged otherwise, awarding her the editorial cartooning prize for cartoons that "... shall embody an idea made clearly apparent, shall show good drawing and striking pictorial effect, and shall be intended to be helpful to some commendable cause of public importance, due account being taken of the whole volume of the artist's work during the year."

Telnaes' drawings exemplify these qualities in dynamic, vividly colored, inventively conceived and designed compositions. She captured humorous and

Detail from The Choice, p. 128.

dismaying aspects of the election, conveying unflinching views on the candidates' foibles and flaws and commenting incisively on the U.S. Supreme Court's role in the election outcome.

Admirers of Telnaes' work comment on the elegance of her linear style, which reminds some of the celebrated caricatures of performing artists by the late Al Hirschfeld (1903-2003), as well as the humorous charm of Walt Disney characters. While she praises Hirschfeld highly, she says that he had no influence on her artistic development. As an art student, she did not study great cartoonists' art, but her training did imbue her with strong skills in drawing, design, composition, and use of color. Now, she particularly admires the superb drawing abilities of Pat Oliphant (b. 1935), Jeff MacNelly (1947-2000), Alexander Calder (1898-1976), Ronald Searle (b. 1920), Gerald Scarfe (b. 1936), and Robert Osborn (1904-1994). Searle, Scarfe, and Osborn—all known for their fluid, expressive line—influenced her style the most. She stresses the importance of Herb Block (1907-2001), whose drawing she thinks is beautiful, and whose integrity, knowledge, and keen understanding of ongoing issues continue to impress her.

Telnaes' style strengthens the conceptual content of her cartoons. In contrast with peers who fill their cartoons with descriptive detail and text, she creates spare, clean compositions. Message and image become unified, and manner and meaning are clearly and easily read. She has evolved an intriguing repertoire of caricatures, thematic approaches, and symbols. She creates memorable caricatures based more, she says, on her observations of each subject's character, words, and actions, than on their physical

GLASS SLIPPERS

"That's great. Now may I see some comfortable shoes
I can wear to work?"

Detail from Cinderella's Slippers, p. 135.

features. In *Six Chix,* she humorously reworks familiar songs, sayings, and fairy tales, turning them on end to comment wryly on today's women, who don't live happily ever after. Using Puritan figures inspired by Nathaniel Hawthorne's *The Scarlet Letter,* she also makes observations about present-day constraints on personal liberties.

Her colleagues praise Telnaes' cartoons for their strong visual impact and the forceful opinions they convey. Pulitzer winner Ben Sargent, cartoonist for the *Austin American-Statesman,* stresses the "uncompromising purity of vison that she has and conveys in such a spare, clean, direct style with such great economy in drawing, . . . everything in a Telnaes drawing takes you to the point [and] she displays consistency in this every day."

Similarly, Canadian cartoonist Brian Gable of *The Globe and Mail* asserts that "Ann Telnaes' cartoons are very hard hitting. Why? Her style is very novel, graphic, spare, and elegant . . . she throws away all that isn't central to the point being made. . . . A unique element [in her work] is the interweaving of word with graphic. . . . She works on distinct themes, makes powerful statements, [and] she has a fresh take on women's issues."

Pulitzer Prize winner Joel Pett of the *Lexington Herald-Leader* underscores " Telnaes' high level of passion for communicating clear, strong opinionated points of view, [which] makes her stand out in the field. . . . She has a world view that is well informed and clear and was one of the few making cartoons about the Taliban five years ago."

Detail from Afghan Radicals, p. 99.

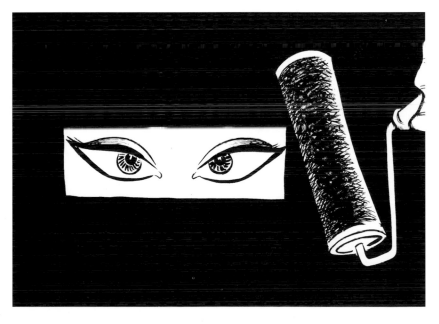

In our age of fast-breaking news, skilled editorial cartoonists such as Telnaes are more crucial now than ever before. Historically, the role of the American political cartoonist evolved from, and still rests squarely upon, the basic civil and human liberties guaranteed by the First Amendment to the U.S. Constitution. Implicit among the rights of self- expression—freedom of religion, speech, and the press—is the right to dissent and criticize one's government. Telnaes has emerged as a leader in the uniquely American artistic genre of editorial cartooning. She bravely expresses opinions that strongly criticize the actions and words of powerful public figures, takes stands on complex and controversial issues, and incorporates humor in form and word. Telnaes has commented incisively on recent key national and international events: the

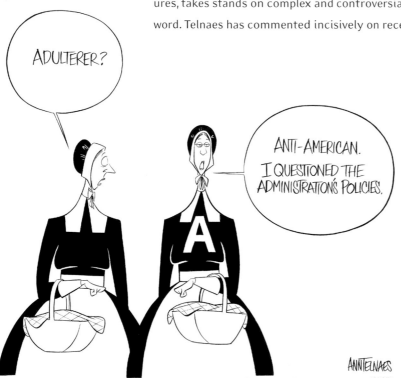

©2001 Tribune Media Services, Inc. All rights reserved 12/12/01

"ADULTERER?" "ANTI-AMERICAN. I QUESTIONED THE ADMINISTRATION'S POLICIES," 12/12/01
Courtesy of Tribune Media Services

In response to mounting concerns from Congress and citizens' rights groups over newly broadened government powers intended to aid in combating terrorism, Attorney General John Ashcroft addressed the Senate Judiciary Committee on December 6, 2001. Instead of covering these concerns, he instead challenged the patriotism of those who dissent: "To those . . . who scare peace-loving people with phantoms of lost liberty, my message is this: Your tactics only . . . give ammunition to America's enemies and pause to America's friends." By showing women in Puritan dress in her cartoon, Telnaes alludes to Nathaniel Hawthorne's *The Scarlet Letter,* an American classic about moral hypocrisy and social disgrace.

2000 presidential election, the terrorist attacks on September 11, 2001, the scandals surrounding certain American corporations, the status of women in the Middle East and Africa, and the wars waged in Afghanistan and Iraq by the United States.

Like her illustrious predecessors and many colleagues, Telnaes exposes the hypocrisy and abuses of power that she sees perpetrated by individuals and institutions who hold positions of high responsibility and public trust. She also focuses particular attention on timely themes such as threats to freedom of expression, First Amendment rights, erosion of the separation between church and state, overconsumption, the role of the media in covering news, and the ongoing denial of women's basic civil and human rights worldwide and at home. Her work affirms the critical role of the editorial cartoon as a powerful means of expressing opinions on, and thereby illuminating, important issues of the day. Telnaes also believes in the genre's potential as an expression of dissent when conditions call for it. In the wake of the September 11 terrorist attacks, for example, she highlighted ways in which heightened security jeopardize civil liberties. At the same time, Telnaes' international background and experiences living abroad have made her aware of how fortunate she and fellow American cartoonists are to be able to express themselves freely. Her abiding aim is to encourage readers to become thoughtfully engaged in the significant public issues that affect their lives.

<div align="right">—Martha H. Kennedy, Exhibition Co-Curator</div>

INFORMATION FOR THIS BIOGRAPHICAL ESSAY WAS DERIVED FROM THE FOLLOWING SOURCES:

Robert C. Harvey, "Ann Telnaes Gets Angry," *Cartoonist PROfiles,* 128 (December 2000).

Chris Lamb, "A 'Capital' Decision for Ann C. Telnaes: After Relocating to Washington, Telnaes Found Success as One of the Syndication's Few Female Editorial Cartoonists," *Editor and Publisher,* 124:41 (October 8, 1994), pp.44–45.

Dave Astor, "Ann Telnaes Is the Second Woman to Win Cartoon Pulitzer," *Editor and Publisher,* 134:17 (April 23, 2001), p.21.

"2001 Pulitzer Prize Winners—Editorial Cartooning, Citation," on http://www.pulitzer.org/year/2001/editorial-cartooning.

Telephone conversations with Ann Telnaes, Ben Sargent, Brian Gable, and Joel Pett, November 2003.

The following interview between Ann Telnaes and Harry Katz, Head Curator of the Prints and Photographs Division and Curator of Popular and Applied Graphic Art at the Library of Congress, took place over two days, on May 12 and May 13, 2003. The transcripts have been edited and reduced for narrative cohesion and flow.

HK: My name is Harry Katz. I'm here today with editorial cartoonist Ann Telnaes to talk about her career and the profession of political cartooning in general. Welcome, Ann, to the Library of Congress.

AT: Thank you.

HK: Thanks so much for spending time with us. This interview is designed to document your career to this point, particularly for the Library of Congress exhibition and book that will showcase your work for a wider audience.

 You live and work in Washington, D.C. Your editorial cartoons have been published in *The Chicago Tribune, The Washington Post,* the *Los Angeles Times,* the *St. Louis Post-Dispatch, The New York Times, Newsday, The Baltimore Sun, Austin American-Statesman,* and *USA Today,* among others. And in 2001, you won the Pulitzer Prize for editorial cartooning.

 That's a lot of accomplishment in a pretty short time. You haven't been an editorial cartoonist throughout your whole career, so I want to go back to where you started to see a little more about where you are now.

 You were born in Sweden. How long did you live in Sweden?

AT: I was born in Sweden, but I'm not actually Swedish. My father is Norwegian and he happened to be working for IBM there at the time. They moved us just about every two years.

HK: Right.

AT: We left Sweden soon after I was born—I was still a baby—but we did return. I went to school there for about three years, first through third grade. So I actually did attend a Swedish school and learned Swedish.

HK: And then from Sweden, you relocated. Where did you go?

AT: Several different places. We've lived in New York, North Carolina, California, because we were transferred so much.

HK: What about drawing and art—what kind of role did they play when you were growing up? When did you first begin to draw? Do you have any idea?

AT: Ever since I can remember, I was always drawing. I don't think I honestly thought I was going to draw for a career until I got into college. I don't think my parents were sold on the idea that I could actually make a living.

HK: You were doing art when you were a kid, with no sense of it as a profession, you just pursued it at school and at home, and—

AT: When I went to college, I sort of made a deal with my Dad. I could minor in art—and it was fine art at the time—and I was supposed to major in journalism.

HK: Something that would actually make good money for you, a trade.

AT: I could have a job—right. But it didn't end up that way. I ended up majoring in art, in graphic design. I was going to be a graphic designer, an illustrator. I went for a couple of years to Arizona State University, and then I decided I needed to go to an art school. That's when I applied for the California Institute of the Arts.

I actually didn't know that much about animation. I just really enjoyed it, like anyone else that's grown up on Disney Films and Warner Brothers. I was accepted, so that's how I ended up doing animation.

HK: So you found a kind of commercial application so you could pursue your art and maybe even develop a career.

AT: Yeah. I could get my parents to accept the fact I was going to study this in college. [Laughs]

HK: What kind of training were you getting as an artist while you were coming up, either through high school or through college?

AT: High school was just basic types of art classes, but once I got into college it was fine arts. You learned life drawing, perspective, and basic color and design. This continued at the California Institute of the Arts. Cal Arts was a really exceptional school for me, because even though I was specializing in animation, I got a full arts education. There was only one class in animation, and the rest of the week you were learning all the basics. My background is really fine arts.

HK: And so you went from school right into the animation field?

AT: Yes.

HK: How did you get from school into working as a professional animator?

AT: Because Cal Arts was a professional school, you kind of got fed into the system. I started out as an assistant animator, and I did some layout work, too, which is basically design work for animation, and then became an animator. But I was only in the animation field itself for a few years. I ended up going to the Imagineering Division at Disney, where I was basically a show designer. I was doing conceptual design work for attractions and rides and things. I was there for about six years.

HK: Did you just work with Walt Disney, or did you go on to do other animating, or right into editorial?

AT: I worked in various studios.

HK: Did you work for Warner Brothers?

AT: I did freelance Warner Brothers stuff, but that wasn't animation. That was more licensing art, and I was doing that as a supplement to my income.

HK: Okay.

AT: I was trying to get out of Disney and find work on my own.

HK: What did you learn, though, from Disney, from being in that environment? What did you learn from being an animator—the skills, the techniques, the actual business of being commercial or trying to sell your art?

AT: Like I said, I was only in the professional animation field for a couple of years. I worked for smaller studios. I worked overseas for awhile. I didn't really enjoy it, because in school, when you're in animation, you get to do everything.

You come up with an idea for your film—you have to have a film at the end of the year. Just a couple of minutes, a pencil test. You get to design the characters, the sound recording, you get to do everything.

And I loved that. That was very creative. But once you get into the actual field, it's more like building a car. You have a specific thing. You're an in-betweener, you're an assistant. And I didn't find it very stimulating creatively. So that's why I decided to start working for Imagineering.

There were a lot of talented people that worked in Imagineering. I was able to develop my art skills, because I was drawing, I was doing conceptual work, all the time. It was a positive experience, but it was long enough for me to be there. I needed to go on. I think you can kind of stagnate a bit, if you're not careful, because you are doing someone else's work.

HK: So what made you think about being an editorial cartoonist? Had that been a long-held idea? Where did that come from?

AT: I've always liked editorial cartoons, just from an artistic standpoint. But no, I wasn't very politically aware, I'm kind of embarrassed to say. I just wanted to be on my own. I didn't really know what I wanted to do. And there were a couple of things that happened. Once, I was working late into the night doing a freelance project, and I happened to have the television on during the Tiananmen Square incident.

I watched the whole thing unfold on television. And I have to say, that had quite an effect on me. I was really shocked by it, and I did my first political cartoon. And—

HK: You didn't do it for anybody?

AT: I just did it for me. Because I had to, because I was so mad. I was probably also really pumped up on coffee, since it was so late. But I had to do it. And then the Anita Hill hearings happened. I watched those on television. I was getting more aware of political events. That's when I started doing my own cartoons regularly and trying to get them published anywhere.

HK: You would just produce them at home?

AT: I'd just do them myself.

HK: How did you make contacts? What avenues did you take to get your work published?

AT: I found addresses of newspapers and started sending my work out and getting rejections. At the time, I was working in Los Angeles.

HK: Were you looking for a job as an editorial cartoonist, sending them a portfolio, or what were you doing?

AT: I was trying to get anybody to run my cartoons, so I was just sending pieces out.

HK: Okay.

Detail from "You kids stop fighting," p. 66.

AT: And the *Los Angeles Times* used me to do a few—

HK: Based on a portfolio that you had submitted cold?

AT: I sent out brochures that I had made. They said yeah, they'd run a few.

HK: And when was that?

AT: That was early, 1990, '91. In 1992 I started getting published regularly by a few different newspapers that were interested in my work.

HK: You were still not affiliated with a syndicate?

AT: No.

HK: You would submit your work, and they would just pay you for whatever—

AT: Piece by piece.

HK: So I guess you had become somewhat politicized by current events, contemporary events.

AT: Right.

HK: Well, let's talk about your early editorial career. How long did it take for you to go from doing this on your own to getting syndicated?

AT: As I mentioned, I started becoming regularly published in '92. I became syndicated in 1994 by North American Syndicate, which is part of King Features. It was a package that had a group of cartoonists, about twelve of them. They would send out five cartoons a day on a rotating basis. And I had won this little contest with a monthly comic newspaper called *The Boston Comic News* [later *Editorial Humor*]. Every year they had a contest for all their nonsyndicated cartoonists. They would send the winners off to the syndicates. That's where they first saw my work. They had me send in some things—they wanted to see if I could do something regularly for about four months, and then they asked me to join the group. I've been syndicated ever since. I've moved around, but I've never worked on a paper, just always been freelance.

HK: You don't work for a particular newspaper. You're syndicated. There are others in the field—Pat Oliphant, for example—who do the same thing. Would you like to work for a newspaper?

AT: You know, I kind of fluctuate with that. I'm not so sure anymore. I think, in the early days, it would have been nice to have a regular forum.

I like the freedom now. I think the more I've talked to my colleagues and find there are different situations with editors—some are very good. Some are not so good. I don't really know how well I would take to having someone tell me what to do. [Laughs]

HK: Yeah. So there is a tradeoff. On the one hand, you're syndicated, which means, practically speaking, you draw whatever you like. There's no editorial control over your idea or your drawing.

AT: Not so far.

HK: The editorial control comes in when the syndicate sends out your work and newspapers either do or don't choose to use that particular image on that particular day. So that leaves you free to pretty much say what you think.

AT: I kind of enjoy that. [Laughs] I know the limitations there can be when you're on staff, since I've heard about them. I think I like what I'm doing now. And I have to admit, ever since the Internet has come into play, it's even better for me. Because even though an editor doesn't necessarily want to run anything, I can put it up. Which I do.

HK: Right. You actually do make drawings, there's no doubt about that, but when you make them, you don't have to be in any newspaper newsroom. You can work wherever you are. You need a scanner. And you need a modem.

AT: I need a phone line or something else.

HK: A phone line. A scanner. You do a big drawing and then you simply scan it.

AT: Then I'll color it on the computer and put it up on my website. It also appears on other ones.

HK: People can have access to it there. They can see it. Could they also use it somehow, if they—

AT: They'd better not. [Laughs]

HK: —if they come to you.

AT: Or my syndicate, yes.

HK: But they can certainly see it. What is your web address?

AT: It's www.anntelnaes.com.

HK: Okay. So in a way, you're somebody in transition. A lot of cartoonists go straight to electronic or digital, but you're still creating a drawing and then using the digital—

AT: I still enjoy drawing.

HK: Well, thank goodness, because they're a lot easier to store than digital files, so we're happy about that.

Can you take us a little bit through the process that you go through from an initial idea, concept, of a drawing in your head to a finished piece, and then how you disseminate it?

AT: I'd like to tell you there's an easy, clean way of doing it, but all day long, I just kind of jot down either notes to myself or ideas. I'm always leaving scraps of paper everywhere.

It's an ongoing process. I read papers, I listen to the news on the radio and the television. Maybe something will hit me right away, maybe not. I go through dry periods, too.

I find the cartoons that turn out the best, that are the most powerful, are the ones about subjects that I've actually been thinking about for awhile. It's not necessarily something that's just on the

front page. It's an issue that maybe I've read a story about, and then I come back and I read some more, and all of a sudden, I get a great idea.

HK: Do you come up with an image that is graphic, or do you first have an idea that is going to be the focus, then think, now how do I draw it? Is it the image or the message that comes out first?

AT: It can be the image, but I think it's more that I have a point I want to make. What's the best way visually of making that point? It's a lot of back and forth, but I have to first know how I feel about a subject matter. Once I know that, if I want to say, "This is silly," or "This is incorrect, this is hypocritical," then I'll go from there. I'm trying to come up with visual images that fit a subject and make the point strongly.

But having said that, sometimes I'll jot down images that would make a strong point, but I don't have an idea for them yet. Maybe down the road I might use it.

HK: You're developing a vocabulary, do you feel?

AT: Yes.

HK: Do you think in terms of symbols, or do you take each cartoon as it comes?

AT: When you say "symbols"—

HK: You have some themes that you keep coming back to. You're going to be drawing from your personal viewpoints, values, attitudes. Could you describe the way they translate into a drawing as a repertoire of symbols that you use to focus your argument for people to respond to?

AT: I do that with certain subjects. I do a lot of cartoons about women's issues, obviously, because that's something that I personally have a relationship with. I did a series of drawings about women in Afghanistan under Taliban control. I had read a story about it in, I guess it was '96. I just thought the situation of these women being under such a regime was horrendous. They couldn't go out of the house, or if they did, they had to have a male family member with them. They had to wear the burka so the only thing you

could see was their eyes. The burka was such a great visual image for me to use in my cartoons, and I kept coming back to it.

HK: So the burka kept coming back in your cartoons?

AT: Besides the fact that everyone would instantly recognize what it was, it was such a wonderful image to put in a drawing.

HK: It's a strong, graphic element—

AT: You can read it very quickly and you know what I'm talking about.

HK: It represents oppressed women, particularly in that fundamentalist tradition.

AT: Right. I think when you first said "symbols," I was a little bit worried, because we talk about overused symbols sometimes in political cartoons.

HK: What are some of those?

AT: Oh, Uncle Sam, the elephant and the donkey—which I have used, but I find myself getting more and more away from them because I'm trying to find newer ones.

HK: What are some of the other symbolic images that we can pick out of your work, aside from the burka? What other themes and symbols that you've used have lasted, at least in your mind?

AT: For anything that pertains to Americans' overconsumption of oil, of food, of anything, I always draw a very large person who has a big belly. I use that image continuously, which I do get criticized for sometimes because, obviously, people take offense when I draw large, fat people.

But it's a great visual image, too, because the whole issue of eating and consumption—

HK: Well, there are conventions in cartooning along those lines. A capitalist, in Robert Miner's day, was a big, fat capitalist. In James Gilray's day, there was the corpulent, corrupt politician. Do you look back at other cartoonists' work, by the way?

AT: I did in the beginning, but mostly at contemporaries. Some of my really early work looks it, too. It doesn't look anything like what I do now. You're basically copying other

people because you're not comfortable enough in your own style. Like I said, I was still like everyone else. I was using the donkey and elephant all the time, to symbolize the Democratic and the Republican Party, or Uncle Sam. Sometimes it's better to use them, because that's what you're trying to say. But it's also fun to come up with something different.

HK: There are two artists that we lost within the past couple of years that I would think were of some interest to you. That would be Herbert Block and Al Hirschfeld. Now, I bring up Hirschfeld because he was a wonderful theatrical caricaturist who would try to fix what he saw on the stage in a line on paper. I think, stylistically, you use the line. And there's a very Herblockian quality in the way you focus on a spare image, a quick text, and a potent, unified message. There are very few artists in the editorial field that are able to unify their message and image in the way that you do, and that's also something Herblock could do effectively. Do you see any influence on you of these men's work?

AT: I admire both of them. Both had beautiful drawing skills. But I have to say, many people have asked me, "Has Hirschfeld been one of your influences?" And he really wasn't. I was aware of him, but I didn't study him in art school. I studied people like Ronald Searle. I loved his work. I loved [Robert] Osborn's work too, which has a very fluid line. It's very loose, which I wanted so badly to do. I also love [Gerald] Scarfe, because his humor is so intense.

HK: They're all very expressionist cartoonists. Was that something you were trying to put into your work?

AT: I think my style actually comes more from the classes that I took at Cal Arts. We had an incredibly strong design teacher who taught that there should be one visual point in a drawing. You learn that in design. You learn about positive and negative spaces, about leading your eye a certain place.

My design teacher there was just wonderful. He inspired fear in everyone, but if you could grab on to what he was trying to teach you, it was like a light going off in your

head. His name was Bill Moore. I also think the way I use line comes from the fact that when I first started doing editorial cartoons, I had trouble doing them fast. You've got to do them fast. I was using zipitone, doing crosshatching, which take time. But while I was working freelance for Warner Brothers, I had learned how to use a brush and ink, because that's how you do the drawings they use on products. You have to do a beautiful line all the way around it.

So I started using that technique, because I was very comfortable with it. All of a sudden that and my design training were working together.

HK: Going back to Herblock, what do you think he represents and represented?

AT: The thing about Herblock that I have always found so amazing is that he could draw. There're very few editorial cartoonists that can draw really well. I would say Herblock, Pat Oliphant, some of the older guys, and [Jeff] MacNelly.

Herblock was very good at having a point of view and showing it in his drawing. He did his research. He knew what he was talking

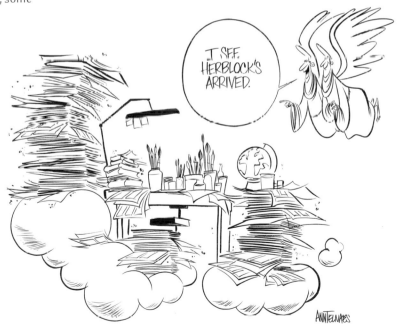

"I SEE HERBLOCK'S ARRIVED," 10/8/01
Courtesy of Tribune Media Services

Legendary editorial cartoonist Herblock died on October 7, 2001. "It was almost too much for me to come up with something worthy of him," says Telnaes. "He could draw really well, he did his research, he knew what he was talking about. He was ahead of everyone else, and he was such a nice guy. But as soon as I walked into his office, I thought 'boy, I thought my office was a mess.'"

about. He was ahead of everyone else. He wasn't just reacting to news, he was actually thinking about the consequences of what was going on out there.

HK: That's right.

AT: So many of us just react to what's in the day's headline, and do a cartoon that isn't really taking a stand about anything. An illustrative piece of news is not editorial cartooning.

That's what I think Herblock was so great at. You can look back at his work, at the dates, knowing now what went on in history. He was years before his time.

HK: Obviously, you want to be a successful cartoonist, but what really motivates you, in terms of the work? Are your politics personal? Do you see yourself as taking a risk when you take a certain political stand?

AT: Lately. [Laughs]

HK: What kind of hidden forces are acting on you?

AT: When I say "risk," compared to what other journalists and cartoonists go through in the rest of the world, we don't have much risk here, at least not yet. And I don't have a political agenda. That's not what I'm doing this for. I think in editorial cartooning, you should be willing to strike at whomever is doing something you think they shouldn't be doing and that needs to be exposed. Even though I'm very liberal in my outlook and my cartoons show that, I have absolutely no problem doing a cartoon that blasts either political party, or liberals or conservatives.

HK: Obviously, you've accomplished so much in what is, in effect, a twelve-year career as an editorial cartoonist. You've reached the heights of a Pulitzer. What is it that you're consistently bringing to your work? What propels you to really focus yourself and drives you every day?

AT: Well, there are certain issues that always get me going. [Laughs] The whole thing about religion and politics—

HK: So separation of church and state.

AT: I'm a firm believer in separation of church and state. Nowadays, with religious organizations that are basically political organizations, I have plenty of subject matter.

I think anything having to do with abuse of power motivates me. That goes for politics and religion, as well as organized religion. I've done a lot of things about the Vatican and its influence throughout the world because it affects so many women that aren't even Catholics in terms of family planning. Or the recent scandal about sexual abuse of boys we had here in the United States—I did a lot of cartoons about that. That's a difficult issue, because some people take cartoons like that to mean you're criticizing Catholics in general. For example, I drew a cartoon suggesting that the Vatican had tolerated or known something about the sexual abuse that had been going on, and I linked it to the rejection of legalizing same-sex unions. That cartoon in particular created controversy. There was an op ed piece by a chancellor of the Archdiocese in the *Minneapolis Star Tribune* and letters to the editor against it. But I wasn't criticizing Catholicism or Catholics. I'm criticizing the organization, the leadership of the church. There were also letters to the editor in support of the cartoon.

Another controversial topic I do a lot of work about is family planning—anything that affects a woman's reproductive health. That's always a hot button issue here in the United States because of the abortion question.

I'm concerned with overconsumption. It touches on our energy policies and our recent foreign policy. If you really want to be simplistic about it, I always look for abuses of power and, frankly, hypocrites. I think people that have a public forum have a certain responsibility. If they're being hypocritical, or if they're abusing their power, they should be exposed.

HK: Do you see yourself as journalist, educator, activist? What parts of all of these fit?

AT: I think everyone that lives in America should be able to express themselves and get involved, and this is how I do it. I don't look at myself as being a journalist. I don't have

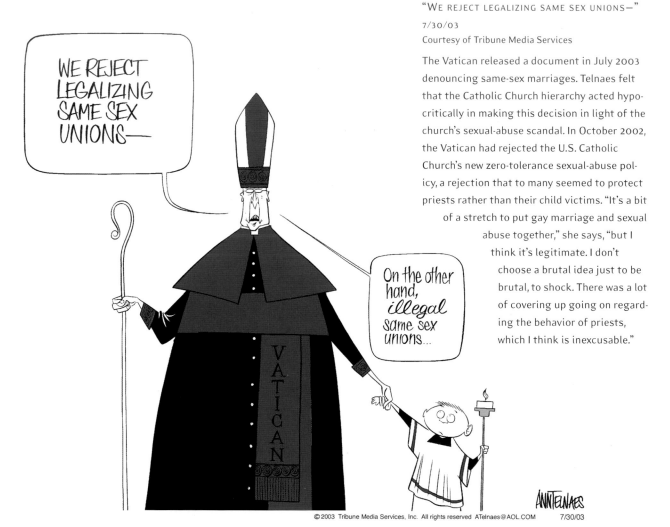

"WE REJECT LEGALIZING SAME SEX UNIONS—"
7/30/03
Courtesy of Tribune Media Services

The Vatican released a document in July 2003 denouncing same-sex marriages. Telnaes felt that the Catholic Church hierarchy acted hypocritically in making this decision in light of the church's sexual-abuse scandal. In October 2002, the Vatican had rejected the U.S. Catholic Church's new zero-tolerance sexual-abuse policy, a rejection that to many seemed to protect priests rather than their child victims. "It's a bit of a stretch to put gay marriage and sexual abuse together," she says, "but I think it's legitimate. I don't choose a brutal idea just to be brutal, to shock. There was a lot of covering up going on regarding the behavior of priests, which I think is inexcusable."

Star Tribune Editorial

Letters from readers

Offensive cartoon

The Aug. 4 editorial cartoon showing a cleric holding the wrist of an altar boy, saying, "We reject legalizing same-sex unions. On the other hand, illegal same-sex unions . . ." is the most offensive cartoon I have ever seen. The implications are obvious and disgusting. You have outdone yourselves.

Eric J. Evander, Victoria.

A disgusted Catholic

An Aug. 4 Ann Telnaes cartoon implying that the Vatican in some way condones the sexual abuse of minors is despicable.

Shame on the Star Tribune for being so cruel about this serious issue that Catholic leaders have been doing their best to deal with fairly and compassionately.

Cheryl Himsl, Golden Valley.

Out of line cartoon

I find myself in the unfamiliar territory of defending the Catholic Church. I admit it crossed my mind that perhaps the Catholic Church is not in the best position at this time to be issuing moral declarations on gay unions.

However, the Aug. 4 Ann Telnaes cartoon depicting the Vatican as eager to join in the victimization of children was tasteless and unfair.

Robert Waterman, Falcon Heights.

Solving abuse problem

Regarding the pope's recent reiterations against gay marriage (Star Tribune, July 29), wouldn't you think there'd be a decent chance that encouraging gay marriage or civil unions might be one way the Catholic Church could help solve its internal problems of sexual abuse?

The church runs the risk of being a textbook case illustrating the damage that can be done by culturally thwarting otherwise benign and beneficial natural instincts.

Jim Dustrude, Mound.

Freedom to draw

There is something called freedom of the press, a completely novel idea instituted by our forefathers. We are fortunate enough to have this freedom in our country, and, in response to an Oct. 23 letter writer, the Catholic Church does not "deserve" an apology for the Oct. 22 Ann Telnaes cartoon.

It was merely depicting one person's opinion, something quite common in every newspaper.

Megan Zadach, Eden Prairie.

A hurtful doctrine

Unfortunately, Ann Telnaes' Oct. 22 cartoon depicting the pope as responsible for numerous unwanted pregnancies is totally accurate.

And because the Catholics in Europe and North America are too well-informed and independent to follow the pope on this point, almost all of these unintended pregnancies occur among poor, uneducated populations in the developing world, perpetuating their misery.

Therefore, the Catholic Church does not deserve an apology from the Star Tribune (or Ann Telnaes) but owes an apology to the millions of poor people who followed, or are the result of, its doctrines regarding birth control.

Simon Oosterman, Minneapolis.

Cartoon crossed line with a slur on church

By William S. Fallon

Forget political correctness and equal treatment of all faiths — at least within the editorial decision chambers of the Star Tribune. Ann Telnaes' Tribune Media Services cartoon at the bottom of Monday's editorial page is a bigoted, tasteless and distorted attack on the Roman Catholic Church, its clergy and all Catholics.

Unquestionably, some clergy in our church have committed grave sins that have wounded young people and besmirched the reputation of all religious, but to use the Vatican's recent same-sex marriage document to portray the "Vatican" as lecherously winking at "illegal same sex unions" and pedophilia is a vicious and unfair slur against our church, its religious and its lay faithful.

It is unthinkable that the Star Tribune would publish a similar editorial cartoon demeaning Mormons, the Jewish religion or the Muslim faith. Yet, again and again, the same taste and fairness constraints do not apply to Roman Catholics.

G.K. Chesterton once wrote that "Anti-Catholicism is the Anti-Semitism of the Intellectuals."

Is that the all-knowing rationale the Star Tribune uses as an editorial judgment standard?

William S. Fallon, of St. Paul, is chancellor of the Archdiocese of St. Paul and Minneapolis.

any training in it. I'm certainly not a reporter. And I don't consider myself an activist, because I don't join groups that way. I just want to work on my own. I think it's an expression. For me, the thing that I do best is draw, and so I use it.

HK: When you look at the body of your work from the last ten years—

AT: I want to throw half of it away.

HK: That's fine, but do you feel like you're working with more clarity? Is there a more self-aware approach to what you're doing? A quality, or values, that you would like people to take from your work?

AT: I feel like I'm coming back toward my fine arts roots. Rather than doing a cartoon about one subject one day, the next subject the next day—which I've been doing for years because of the nature of the business, I find now I want to do topics. I would love, for a few months, to do just one women's issue. It's not that easy when you're supposed to be working on different topics.

HK: It's interesting, though, to conceive of that. Now with *Six Chix,* you're working in the narrative framework of the comic strip. Walt Kelly did *Pogo* books. Is that what you mean? Almost a graphic novel approach, a series like the campaign that [Thomas] Nast did against Boss Tweed, compressing a matter of weeks or months or days?

AT: Actually, ever since September 11, I've done a lot about civil rights or the whole issue of oil and our foreign policy. You just have to keep coming back to the same topics. That's the one thing I've found. I'm waiting for someone to question me about it, like my syndicate or editors.

HK: Do you get feedback?

AT: Oh, yeah.

HK: What kind of feedback do you get? What are some of the hot points?

AT: Hot points. [Laughter]

HK: A good euphemism for it.

AT: The war in Iraq. You think it would just be the question of whether you are for the war or against. You think I would get a lot of hate mail, because I've been doing a lot of cartoons where I harp on the oil company ties to the administration, for example. I have received some hate mail, but I've also gotten many e-mails from people who say, "Thank you for doing this. It's good that you're talking about it."

I think a lot of Americans are really confused. On the one hand, people want to support the troops, obviously, and on the other hand, they're questioning the whole reason why we're there. That's something I've noticed in the e-mail response. It's not just people writing to tell you you're an idiot. It's also people saying, "Please keep doing it."

HK: How is the landscape with respect to censorship in terms of editors, and also in terms of your ability to express yourself?

AT: At the moment, I don't feel any pressure not to express myself because, as I told you, when you have the Internet, you can express yourself until someone pulls a plug on you. But I've listened to a lot of colleagues' stories. And yeah, there is definitely a type of censorship out there. Editors and publishers don't want to run certain cartoons. And they won't. It's not happening to everyone, but it has happened. You can see it in the quality of the editorial cartooning, too. There's not always a lot of hard-hitting stuff, and that's a form of self-censorship. When you think that you're going to have trouble, you might unconsciously tone down your work.

HK: Is there a role or a responsibility for the cartoonist beyond just making the deadline?

AT: I think so. Of course, I can say that. I don't have a job I have to lose. [Laughs] But I think so.

Since I didn't start out being an editorial cartoonist, I know there're other jobs out there that you can make a living at doing artwork. I think that if you choose to be an editorial cartoonist, there should be a reason. Sure, you like to draw, but you have to want to express a point of view. You have to be comfortable with the fact that maybe that point of view isn't going to be something that people want to hear. I understand people that have

family obligations, but I think you have to decide at one point how much you're willing to give, what you stand for.

HK: You were the second woman to win a Pulitzer in editorial cartooning. Signe Wilkinson won a few years ago. There aren't many of you in the field. Talk a little bit about that. Was that kind of a challenge to you or was that just not an issue?

AT: Besides my ignorance in getting into this business that I didn't know anything about, I also didn't know there were no women in it. [Laughter]

HK: That didn't stop you.

AT: It didn't. Animation didn't have many women in it either. I don't think of that when I go into things. I just do what interests me. But having said that, there are even fewer women in editorial cartooning than there are in animation. I don't know why it is. I think it has to do with the fact that editorial cartooning is a very powerful form of art. At least it should be. And you have to be very aggressive in it, you have to be assertive. You have to take a stand and say something.

And at least when I was growing up, girls were considered more attractive if they were not aggressive. If you were aggressive in a business situation, you were called a bitch. If you were aggressive as a male in a business situation, you were seen as a guy that can get the job done, and you were admired for it. I don't think women are necessarily admired for that. I think that's the reason girls don't become editorial cartoonists. It's changing, though. More and more girls do things that aren't considered girl things, for instance, sports.

HK: Are there other women in the field that you admire?

AT: I admire Signe [Wilkinson's] work, completely, because she has some of the best ideas out there. And Etta Hume at the *Fort Worth Star.* She does wonderful work. She's a very funny lady, too. What I like about people like Signe is that although this is a very competitive field, she's always very willing to help. When there're a lot of egos involved, that doesn't always happen in editorial cartooning.

HK: Let's talk about your adventures with the Pulitzer.

AT: [Laughs] Adventures, yeah.

HK: Talk a little about the body of work that they selected and then about what you think that means.

AT: It was for a body of work that I did in the year 2000. A great deal of it had to do with the 2000 presidential election between George W. Bush and Al Gore.

HK: You submitted how many drawings?

AT: I submitted sixteen. You can go up to twenty.

HK: So you self-selected those out of your body of work for that year.

AT: But there's a problem being a freelancer. You have to prove that what you pick had been published. You have to have newspaper clippings. But being a freelancer, you don't have those at your fingertips, so I spent most of my time trying to find which cartoons actually had a piece of paper to prove it had been printed. That's how I picked my Pulitzer package, which is frustrating, because you're not necessarily picking the ones you want to pick. You're picking the ones you know have been published.

As I do with all these things, I waited until the last minute—I think it was the day before the deadline—and I rushed through all my stuff, with my husband saying, "Why do you always wait 'til the last minute to do this? Why don't you do this before?"

I rushed off to FedEx and got it in on time, and then basically forgot about it, because I didn't even entertain the thought that I would win. One day I got a call from a colleague—there're a lot of leaks in this business—and he had found out who the three finalists were about a month before. And I was one of them, which was thrilling.

And totally unexpected, and wonderful. I didn't have any hopes of winning it. I just was really pleased I was nominated. My husband made a really big deal of saying, "You know, honey, you're not going to win the Pulitzer this year. You will one day, but not the first time you're nominated." [Laughs] I completely believed him, and it was good.

HK: You kept your expectations low.

AT: I didn't worry, like a lot of people do. The day that they announced them, I wasn't in a newsroom, so I didn't have any people sitting around waiting with champagne bottles. I was working at home, and I was online, and a colleague had said, "You can find out if you go to the Freedom Forum website. They'll read it off as it comes over the wire."

And I said, "Okay, fine. I'll look just so I can get back to work, because this is really ruining my day. I have a deadline."

So I'm sitting there drawing away. And then they read it, and I—honestly—all I remember is standing up and saying, "Oh, my God." I didn't even know what to do. I was so shocked that I just—we have a dog. I take him for walks every day. So I said, "Let's go for a walk." That's what we did, while my phone started ringing off the hook.

HK: What do you think people are responding to in your cartoons? What do you think you're doing right in terms of conveying your message on a consistent basis? What are the lessons you're learning about how to make your work better?

AT: I think anything that happens, for good or for bad, has to do with a combination of being ready, making sure you know what you're doing, luck, frankly, and timing. I've heard the negatives about Pulitzers, and I know perfectly well what can happen. I think that I was very lucky. My work was a little different looking, maybe, a different style. That's probably attractive, when you've seen the same style over and over.

And I did cartoons on the 2000 election for a whole month straight, so I had something to pick from. You know, I'm very flattered to win it, but I don't do this for prizes. You can't do this for prizes. You're going to end up getting really disappointed. I just do the work, because I enjoy it, I want to do a good job. If something comes of it, fine, and if it doesn't, that's okay, too.

I think a lot of people can get wrapped up in awards, and it's not healthy for you or your work. It's best to ignore it.

Detail from Florida
Legislature, p. 129.

HK: You've really found a style, a distinctive style.

AT: Time to change it. [Laughs]

HK: Is it time to change it, or is another way to advance your message to have people recognizing your work? Are you consciously evolving a signature style and repertoire of symbols so people will see your work and say, "This is Ann Telnaes"?

AT: I'm going to tell you something right now. I'm not going to stay in editorial cartooning for the rest of my life. Because I always think, if you really want to be an artist—and I really do think that's a lifelong pursuit—you're going to keep changing. There's too many things out there that you can try.

I just keep working and exploring, and that, I think, will ultimately change lots of things—the style, the approach, the subject matter.

HK: Are you headed toward art or commentary?

AT: I think the reason that I decided to do editorial cartooning is because it combines art with commentary. Before that, I was just drawing. That's fine. But for me, what really clicks is being able to take art and your thoughts and make a statement. To put it all together. I think I'll do that for the rest of my life. I just think that the medium will change. I'm sure it will. I'm already itching to do something different. That's what makes it interesting.

HK: One aspect of your life I'm curious about. You were born abroad, you've spent some time abroad. Has your outlook broadened because of that foreign exposure? Do you have more of an objective perspective than your peers, do you think?

AT: Maybe I'm a little more aware because I have lived abroad, and I'm a naturalized citizen. I became a citizen when I was a teenager. I'm in that middle position where, even though I'm an American citizen, and wanted to become one, I'm more sensitive when it comes to foreign policy. I try to put myself in the other side's shoes.

I find that when you get criticized by people for being anti-American and they find out you've been born abroad, they always say, "Why don't you go back where you came from?" I'm especially sensitive to that. That always gets my hackles up.

It has to. Because I've lived abroad, and every time I travel it seems as though, when they find out you're an American, they want to discuss issues with you.

HK: Obviously, with the First Amendment freedoms that we have, there's a great protection for editorial cartoons in this country. Have you talked with cartoonists around the world about that? Have you had thoughts about what it means to be an editorial cartoonist in America as opposed to elsewhere in the world?

AT: Oh, yeah. I'm also involved with the Cartoonists' Rights Network. I'm on their board of directors, and I've traveled for them out to Ukraine. Yes, I've talked to them about free speech issues, and I guess that's why I tend to do a lot of work concerning First Amendment rights. I know it's quite a gift we have, and we definitely take it for granted. Then I see other cartoonists in very dangerous positions for just expressing themselves.

That's why when people ask, "Are you being controversial in your work? Is it frightening?" I say, no. I have my First Amendment Rights. There are a lot of other editorial cartoonists and journalists that are in a lot more precarious positions than I am.

HK: I think for us here at the Library it's a critical issue, because the fact is, we preserve and promote these materials, which, in effect, often criticize the government or attack the institutions. And yet the very fact that the Library of Congress itself is supporting this preservation and presentation of critical material I think is a really good sign for our democracy. How many other national libraries are showing the kind of political work that we do? Does that make you feel pretty good?

AT: Oh, yes. I definitely support what you guys do. This is where I'd like my work to end up, in this type of institution. I think it is important.

I, myself, love to look back in books, see drawing and writings and personal bits of history, because it brings the past closer. I think it's important to express myself on social issues and things that impact ordinary people, to keep a record.

HK: Let's take a look at your drawings. We've got a selection here, and we'll try to bring out some of the principal issues that you've been working on throughout your career. Then we can talk about particular drawings, or events, or people that you want to discuss a little further.

Let's see. This is a good one. This is Rosie the Riveter and an image you often use to refer to the Taliban, the burka.

AT: Okay. This cartoon was done fairly soon after 9/11. The Taliban were in Afghanistan, and I think Americans became really aware for the first time that their attitude toward women was especially disturbing. They didn't allow women to work. They didn't allow women or girls to go to school. Health care wasn't available, because, of course, you couldn't have a male doctor, and they wouldn't allow the women to be doctors. So I decided to do this image of Rosie the Riveter, because right after 9/11 American feelings were running pretty high, and we were thinking back to Pearl Harbor. Rosie the Riveter was a very potent symbol of women during World War II, women helping the war effort as well as being working women, which was a new concept.

I thought it would be very interesting to show that image and then show the Taliban completely painting over Rosie the Riveter, except for her eyes—which goes back to the image of the burka, this cloth draping a woman's entire figure. The only thing you can see are her eyes.

HK: Now, let's take on President George W. Bush. This one is "The World According to W." Tell me a bit about how you develop caricatures for new figures. When Bush took office, how did you develop his caricature?

AT: It's always a difficult thing, especially when you get a new president, because caricaturing for me has more to do with a person's personality and attitudes than their

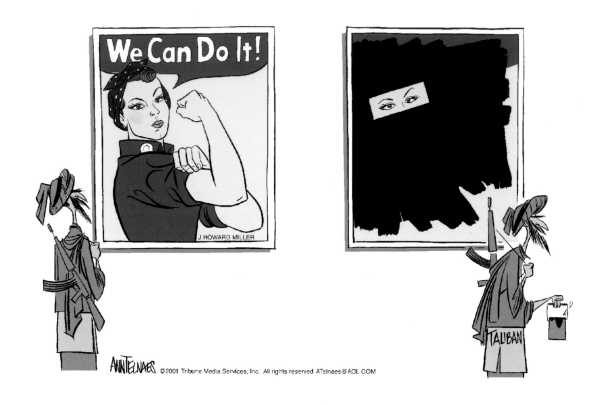

WE CAN DO IT!, 9/25/01
Courtesy of Tribune Media Services

In the wake of the September 11, 2001 attack on the United States, Telnaes asked Americans not to overlook the suffering of women in Afghanistan, who have endured severe restrictions since the Taliban took control of their country in 1996. In this cartoon she contrasts a famous World War II poster of Rosie the Riveter, which encouraged U.S. women to join the war effort, with the Taliban's efforts to make their women invisible members of society.

looks. I'm always floundering in the beginning. That's a pretty early Bush. I'm not real happy with that Bush.

The people you draw have to have sort of a track record with you. You have to observe them on television, or in real life if you have that opportunity, to really get a sense for who they are in a caricature.

The more I get to know someone and listen to him speak, find out what his policies and thoughts are, that shapes the caricature for me.

HK: As you look back, are there particular moments when you thought that a cartoonist had really gotten somebody down? Either yourself or somebody else—

THE WORLD ACCORDING TO W
6/14/01
Courtesy of Tribune Media Services

On June 11, 2001, President George W. Bush embarked on his first notable international tour, hoping to improve public perceptions of him at home and abroad. Criticism of his administration was rampant because of its seemingly indifferent, domineering, or arrogant attitude toward a variety of foreign policy issues, including missile defense and the environment. Other countries viewed Bush as putting the United States at the center of the world. "I think this cartoon says pretty much what I still believe," says Telnaes. "Bush's view of the world was very narrow. And it still is."

The World According to W

ANNTELNAES

AT: I thought when Pat Oliphant came up with the first George Bush, when he gave him a purse. [Laughs] That was so brilliant.

HK: What's the impact of an image like that?

AT: Well, that makes my point. It works because you know that person's past actions, you know his personality. It's a symbol, and it gets you [snaps fingers] just like that. I think probably Oliphant and [Garry] Trudeau do it absolutely the best.

When I started doing George W. Bush during the primaries, I gave him a beanie, which worked well then. Now, I don't, because the beanie doesn't work any more.

HK: You're really responding to your sense of how he's perceived as well. It's not just your perception, it's what other people think too.

AT: Right. After 9/11—I thought this was a little premature—but people started drawing George W. Bush as a warrior. I draw him like a warrior sometimes now, but for a totally different reason, because of the war in Iraq.

But the person that I have actually the most fun with is Vice President Dick Cheney.

HK: What does Cheney bring out in you?

AT: Well, I'm concerned with Cheney and his ties to big business and Halliburton, and the secrecy that he and his office operate under.

HK: How about Attorney General John Ashcroft? Let's see if we can find him. Here's "I want your civil liberties." You're playing off James Montgomery Flagg's poster of Uncle Sam.

AT: Right. I put Ashcroft in a sort of Puritan—

HK: Nathaniel Hawthorne, *The Scarlet Letter*—

AT: —type thing, and I've got him pointing at you and saying, "I want your civil liberties."

HK: What is it about Cheney and Ashcroft that really brings out your—

AT: My wrath? [Laughs]

HK: Your wrath, your passion?

ANNTELNAES © 2002

I WANT YOUR CIVIL LIBERTIES, 12/18/01

©Ann Telnaes

For reprint contact www.cartoonistgroup.com

On October 26, 2001, President Bush signed the USA Patriot Act into law, giving the federal government a wide range of new powers—among them increased wiretapping and electronic surveillance capabilities, greater access to previously private records, and the ability to detain immigrants without legal charges. Attorney General John Ashcroft was the driving force behind the act, claiming that it was necessary to combat terrorism, with others arguing that it threatened civil liberties. Telnaes' cartoon is a new twist on James Montgomery Flagg's poster of Uncle Sam.

AT: As I told you, I think an editorial cartoonist's role is to skewer the powerful politicians that have an impact on regular people's lives. I think Ashcroft has had an incredible impact ever since 9/11, and Cheney is continuing to have an impact in his foreign policy.

So they'll continue to be subjects. Unfortunately for another four years, probably.

HK: Let's talk for a minute about 9/11, because that was obviously a very extraordinary event. Here's one of your drawings on that theme.

AT: That was done, I think, a day or two afterward.

HK: "We interrupt our regularly scheduled program to bring you reality." There is the irony of 9/11 being the most televised, documented TV phenomenon, at the same time that reality TV is becoming ever more popular and influential. You've captured the idea that this is about as real as TV can get.

Talk about your response, but also the response of the profession, of other editorial cartoonists. Are there issues that are just too big or daunting or overwhelming to respond to?

WE INTERRUPT OUR REGULARLY SCHEDULED PROGRAMMING TO BRING YOU REALITY.

ANNTELNAES

"WE INTERRUPT OUR REGULARLY SCHEDULED PROGRAMMING TO BRING YOU REALITY," 9/13/01
Courtesy of Tribune Media Services

In Telnaes' cartoon, a shocked and battered Uncle Sam responds to news of the September 11 terrorist attacks on the World Trade Center and the Pentagon. She also plays on the popularity of "reality television" shows that portray ordinary people placed in contrived situations. "September 11 was a wake-up call," says Telnaes. "Plus, I was shocked. That's really me sitting in the chair."

AT: On a personal level, I live in DC, which is one of the cities that was directly affected. My husband works downtown, so it was a personal issue for me. The first day, I just couldn't do anything. I was a wreck like everyone else.

As for my colleagues, we did have an interesting situation arise out of 9/11. The first week practically everyone drew either a crying Statue of Liberty or something to that effect.

HK: An angry Uncle Sam.

AT: That's right. Those were the two images. [Laughter] And there was a lot of vigorous discussion about that among the editorial cartoonists. I remember, when I started thinking about what I was going to do for my first cartoon, I thought, "I am not going to draw a Statue of Liberty crying, I know that's what everyone is going to do." And they did.

I don't think that many cartoonists can pull something like that off, because you have to have incredible drawing skills. Pat Oliphant is probably one of the very few that could draw well enough to draw something like that and give it the stature that it deserves.

HK: He drew an angry Uncle Sam.

AT: Yes, I know that. I saw it. [Laughter] But he drew it well.

HK: He drew it very well, yes.

AT: What I'm saying is, if you're going to take on something as serious as that, as [Bill] Mauldin did in the weeping—

HK: The weeping Lincoln for the death of JFK.

AT: Which fit. Which no one had done before. If you can draw, you can do an image like that. But unfortunately—and I've gotten a lot of criticism from my own colleagues for saying this—a lot of editorial cartoonists today can't draw that well. I think then that you have to step back and say, "Maybe I should do something else."

The first cartoon I did after 9/11 was a big rat, and I labeled him Terrorist. We didn't know who had done it at that point. It just said "vermin" underneath, because "vermin" has a double meaning, rats or a vile, disgusting person or behavior.

Also, the first couple of weeks—or the first couple of months, depending on where people were working—you couldn't do any cartoons criticizing George W. Bush. You could do them, but—

HK: But what would happen?

AT: Well, you got criticized. People got censored and couldn't run things. Obviously, I could do anything I wanted.

I did a cartoon criticizing George W. Bush about the second week, because he was doing a lot of aggressive talk, swaggering stuff, which has continued to this day. But at the time, I thought, "This is really dangerous to do now."

I got criticized for that from people e-mailing me, but I have that luxury of being a freelancer. Who's going to tell me I can't do it? But a lot of people did have trouble with their editors. So censorship was a big discussion for a long time.

HK: In retrospect, what would you like to have seen?

AT: From my colleagues, or me?

HK: From your colleagues.

AT: I would have liked to have seen a little bit more bravery, frankly. I understand people's personal positions in terms of family obligations, but if you want to be in this business, I think you should be wiling to put yourself on the line. There were people that did that. Ted Rall, a nationally syndicated freelancer, got into a lot of trouble for cartoons that he did, but he's always getting in trouble.

I've been in a lot of different art-related jobs, and I know you can make money drawing in different fields. If you want to be an editorial cartoonist, there's a reason. It's not just because you like to draw. I made that conscious choice.

So, yes, I would have liked to have seen a little bit more bravery, more standing up, more thinking. After you get over the initial shock—I can give everybody the shock cartoon—let's start looking at the real issues. Let's not just start waving flags, like our media did. I criticized the media for that, too. There's still a lot of flag waving.

HK: I want to shift a little bit in direction to the *Six Chix*. In addition to all your political work, you do work with five other women for a comic strip called *Six Chix.*

AT: We have a day each. I do Thursdays, and then we trade off Sundays. We all have very different styles.

HK: Talk a little bit about *Six Chix,* about what it means to do a comic strip.

AT: I've never done a comic strip before, so this is new to me. This one is supposed to be from a woman's point of view, obviously, because we're all women. But we don't want to cover the typical subjects, like weight loss, that traditional strips by women do. I find myself still struggling with this strip, because I want to turn all of mine into political cartoons.

HK: Well, this one is real male bashing. It says, "I didn't touch him. I just said statistically that he's going to die seven years before me."

AT: That's not male bashing. That's just female humor.

HK: Older sister humor, yes. Can you talk a little more about the issues, and maybe the challenge of doing a strip like this?

AT: Like I said, for me it's a personal challenge because I'm always trying to make a political cartoon out of what I draw. But, as you might know, comic strips are done four weeks ahead of time, unlike editorial cartoons, which have to be finished that day.

After 9/11, I started incorporating current events into the cartoon strip, because there were so many wonderful terms that you could use—"enemy combatant," "smoke them out of their caves," and things like that. But the strip is supposed to be from a woman's point of view, so I also keep going back to the theme of fairy tales, because fairy tales are inherently sexist.

HK: Here's "Fairy Tales on Cable—Snow White and Sex in the City."

AT: Yes. Here's another "male bashing."

HK: Yes. You've got the male capitalist with the trophy bride. [See page 55.]

AT: That image is one you just grow up with, in James Bond movies and such. It struck me as funny. [Laughs]

HK: Could your linear style have evolved somewhat from doing storyboards?

AT: I don't know. In storyboards flow is important. How your eye goes from one element to another. But storyboards are usually pretty rough. I think my style comes more from the use of a brush. But I'm definitely aware about where your eye starts and where it ends and how you lead it through the cartoon. You want to make the reader read something,

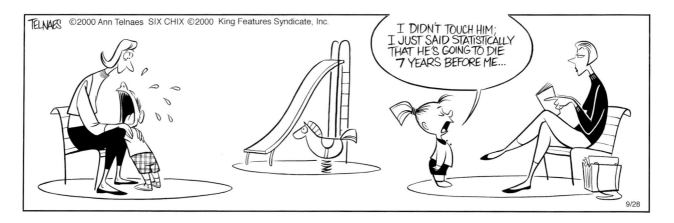

"I DIDN'T TOUCH HIM; I JUST SAID STATISTICALLY THAT HE'S GOING TO DIE 7 YEARS BEFORE ME . . . ," *Six Chix,* 9/20/00
Courtesy of King Features Syndicate

Women may not have all the opportunities men have to succeed in the workplace, but statistically, they live longer. Recent comparative data on the life spans of men and women in industrial market economies (including Western Europe, North America, Japan, Australia, and New Zealand) support the little girl's statement in this example of what Telnaes calls "female humor."

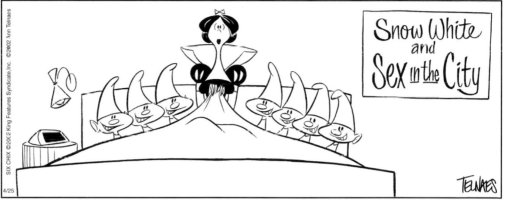

Snow White and Sex in the City, *Six Chix*, 4/25/02
Courtesy of King Features Syndicate

In this cartoon, the story of Snow White is turned upside down. No longer cooking and cleaning for the seven dwarfs, Snow White has joined the ranks of HBO's hip show *Sex and the City*, whose young female stars assert that they have as much right to being cared for and pleased as men. In Telnaes' cartoon, the dwarfs don't look that unhappy either. "On cable, you can do practically everything," says Telnaes. "If you actually had fairy tales on cable, this is the program you would get."

then see something, then read something, then see something. I had some excellent design classes in Cal Arts where I learned that.

HK: This is one where fairy-tale princesses get together and say things like, "Well, let me tell you about MY Prince Charming. Happily ever after, hah!" And "I should have played dead when I had the chance."

AT: That's all taken from fairy tales. If you're a girl, you can identify with that.

HK: I want to talk about how you use your art to really strengthen the power of what you're saying. Talk about the way you use contrast, black and white. That's a key element in these cartoons you submitted for the Pulitzer.

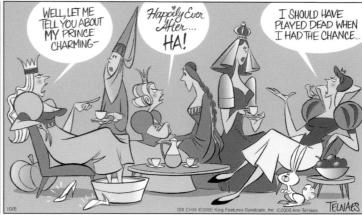

WHEN FAIRY TALE PRINCESSES GET TOGETHER . . ., *Six Chix,* 10/8/00
Courtesy of King Features Syndicate

Telnaes likes using fairy tales in the *Six Chix* comic strip because, as she says, they "are inherently sexist and have great potential for cartoons." In this cartoon, a group of fairy-tale princesses gathers to commiserate and exchange frustrations about how their relationships really turned out. Cinderella, whose glass slippers sit by the tub where she soaks her feet, has reservations about Prince Charming, and Snow White, next to a bowl of presumably unpoisoned apples, also expresses regrets.

AT: The way you use positive and negative space comes from basic design principles. You always have to think about that in your drawing. Using black gets our eye to go to a certain place. A line of action is always very important. This cartoon [see page 56] is a good example of the line of action. The line goes from left to right, the way you read normally. Then all of a sudden, when you've gone through the horse's body to his nose, the one object that's all the way on the right hand side is the beanie. It's basically a win on either side, except Bush is just a little ahead, because he has the beanie.

HK: He's got the beanie.

AT: Yeah. He's got the beanie.

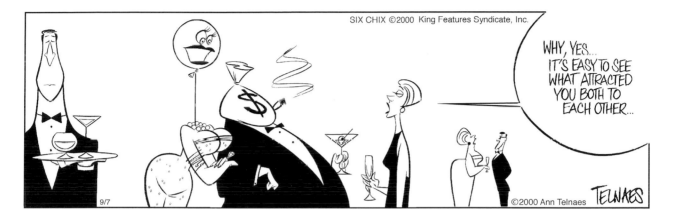

"WHY, YES . . . IT'S EASY TO SEE WHAT ATTRACTED YOU BOTH TO EACH OTHER . . ." *Six Chix*, 9/7/00
Courtesy of King Features Syndicate

Telnaes' cartoon expresses her frustration with the ease with which people accept a May-December romance between an older man and a young woman. "Nobody lifts an eyebrow," she says. "But what happens when an older woman is with a young man?" In this cartoon, it's obvious what each one of the couple sees in the other.

HK: Yeah. He's got an edge.

AT: Since I have an art background, I'm always thinking in terms of leading your eye.

HK: These drawings are so big, Ann. Why do you draw so big when they're going to be repro-duced so small?

AT: Well, they say that small people really have to somehow—

HK: Compensate?

AT: No, that's not the reason. When I was in art school, year after year you take a class in life drawing. They encourage you to draw from your shoulder, not from your wrist, so you're drawing very, very large. I've never been like most editorial cartoonists who

11/08/00

BUSH AND GORE RACING, 11/08/00
Courtesy of Tribune Media Services

Faulty ballots, misled voters, disputed counting of returns in Florida, and more flawed the results of the 2000 presidential election. Telnaes depicts the problematic processing of election returns as a horse race to underscore the fact that historically close numbers of popular and electoral votes determined this election. As Telnaes says, "It's basically a win on either side, except Bush is just a little ahead, because he has the beanie."

draw very small. I don't feel comfortable doing it. I don't draw as well. I'd like to draw bigger, actually.

HK: You'd like to draw bigger.

AT: Yes. I'd like to draw bigger. I need a bigger house. [Laughs]

HK: This is your "Guide to Identifying People by their Headgear, a Sikh, a Muslim, a Jew."

AT: And a racist. That's another cartoon that was done soon after 9/11. We had all those incidents on planes where the pilot wouldn't fly, or the passengers wouldn't go, because somebody looked like he was Arab.

I understand people's reaction, but you have to think things through sometimes. I felt I had to do this—

HK: Have you gotten into trouble using stereotypes?

AT: That's definitely something that keeps popping up when you're doing editorial cartoons. Yes, I do stereotypes, but I think you have to understand how you're using them. I use them to criticize. I'm not doing it to say, "The person always looks like this."

You also get in trouble in terms of caricatures. Sometimes people just do have big noses or big lips. I have gotten criticized for that, as I think all cartoonists do. But that's what we do, you know. That's our language.

HK: The argument goes that any kind of caricature, a negative stereotype can reinforce negative associations. But in your field, there's a sense that you can also use a negative stereotype to make a point. It's the kind of symbolism that people will recognize immediately. Sometimes you have to exaggerate.

AT: Sure. But there's a difference between a drawing like you saw before, a member of the Taliban. He's all scraggly and evil looking with dark eyes, because you're trying to say this man is evil for what he does to other people. But I also draw pleasant-looking women in scarves that are meant to portray women of the Islamic faith. She doesn't look threat-

GUIDE TO IDENTIFYING PEOPLE BY THEIR HEADGEAR, 9/26/01
Courtesy of Tribune Media Services

Balbir Singh Sodhi, a member of the Sikh religion, was killed at his Phoenix, Arizona, gas station on September 15, 2001 because he was mistaken for a Muslim. Singh, like other Sikhs, wore a turban and a beard, but was neither from the Middle East nor practiced Islam. In the wake of 9/11, there were several attacks in the United States on people incorrectly perceived to be Middle Eastern. On September 26, President George W. Bush met with American Sikh and Muslim leaders and reminded Americans not to be prejudiced or intolerant.

ening or evil-looking, but she still has a headscarf on. That's what I think is the difference. I draw plenty of big, fat, white men. Plenty of them.

HK: Have you gotten any complaints from big, fat, white men?

AT: From white guys, sure. They say, "You're always drawing us that way." But I'm using them in place of a politician who is pushing legislation that is going to give a big old tax cut to the top 1 percent. It fits. You don't want to draw a thin-looking, pleasant man. You want to show fat, you want to show big bags of money. It's visual language. But you do have to be careful. All you have to do is look at cartoons back in history. There were cartoons that worked then, but now would make a lot of people very uncomfortable. It has to be in context, I think.

HK: Are there events where you've just said, "I can't go here." The death of Princess Diana, or something like that.

AT: Princess Diana is a good example, because after she died, there was a media glut—the whole 24-hour coverage nonsense. From then on, we haven't stopped. I did a cartoon that linked the two together. The first panel showed someone sitting in front of the television saying, "I feel sad." And the next one, from all the glut, "I feel sick."

That's how I felt myself. It's very sad, but after awhile, it's nauseating.

I don't steer clear of anything—I only steer clear of subjects that I don't have an opinion about or I don't feel strongly about. But I don't think there's anything really—

HK: Do you make that distinction, that even if you have a sense that people are really interested in something, you're not really interested?

AT: I did that more earlier on, because I was going along with the flow. Editorial cartoonists basically do that. They jump around as topics come up. The more I'm in this business, the more I think that's counterproductive. We're not experts in every single field in the world. I'm not expert in anything, except maybe being a woman, since that's what I am.

To bounce around so much is difficult. I want to do the research for everything I draw and there's just not enough time in the day. I find myself wanting to do a series of cartoons on one subject, taking it from different angles. I could. I have that luxury.

But for people who work on newspapers, their editors don't want to see five cartoons in a row on the Taliban. [Laughs] But that's one of the perks that I have.

HK: But you also don't have access to all the information or resources that you might have at a newsroom.

AT: I think I do now because of the Internet. I agree that when I started, I had my own personal clip file, but I remember being envious of some of my colleagues. They would just pick up the phone and say, "I need this," and go down to their clip library and they'd have it. But now, with the Internet, it's a whole different thing. I love it. It's great for research, although I think it's garbage for other things. In the last few years, I have a lot at my fingertips.

HK: Washington itself has played a big role in Herblock's life, in Oliphant's life. What role does being in Washington play in your career? How important is it?

AT: It's not the same as for Herblock and Oliphant, because they both worked on newspapers. I don't know how socially into the city they were.

I just live here. My husband and I are not very social. I don't know anyone. People think you do, because you're inside the Beltway—so what?

But I like living here. I remember when I first moved from Los Angeles, one of my editors said, "You know, your work has gotten better since you got there." I don't know if it's because I'm here and I'm aware more. I don't know.

I definitely like the fact that people in this city are much more interested in current affairs than, say, in Los Angeles. The thing that bothered me about living in Los Angeles and other places in the United States is that when I'm in London, for example, everyone would discuss what was in the news. It bothered me that when I returned to the United States, it seemed as though nobody read the newspaper.

HK: So what do you think your contribution is? Aside from the fact that you're seeing the role of newspapers declining and the role of the Internet rising. What are people doing with your images? What kind of impact do you think you're making? If you go back and look at the Nast campaign against Tweed, for example, there's a lot of good, anecdotal evidence that suggests that over time, political imagery can have an impact.

AT: I don't know how I would know that. You see that from an historical perspective.

Since I'm not on a newspaper, I also don't know if that really applies to me. I do know that with my work on the Internet, I definitely reach a larger audience.

HK: What are people saying to you?

AT: I get a lot of really interesting responses. Women, especially, say, "Thank you very much. That's got me thinking, and I agree." Because of the Internet, I also think I have a lot more international recognition of my work.

HK: You've been in shows and exhibitions all over the world.

AT: Right. But I guess I don't think too much about my work having a direct impact on a specific issue. I just feel like I need to do it. I don't really know if editorial cartoons have all that much effect. I think there have been editorial cartoonists that have been influential in certain situations, but I don't know if my work really applies at that level.

HK: We'll find out.

AT: Well, I'll be dead, so it doesn't really matter. [Laughs]

HK: Are there any other aspects of your career that you want to talk about?

AT: I'd like to do other forms of art, but I think my work will always give an opinion, have a message, whether it's drawing or something else. I don't know what the medium is going to be yet.

HK: But there is a message. Other people see it. Aside from your Pulitzer, you were in the Library of Congress *Women Who Dare* calendar. It recognizes women who have done

something remarkable with their careers, and you're included. What do you think it is about your achievements, accomplishments, that puts you in that company?

AT: I think that even though we're living in the twenty-first century, and you think everyone is all equal and nice and perfect, it's not true. There aren't many women in the cartoon field. I guess that's my accomplishment.

But we have come a very long way. For women my age, there was a definite change in society when we started in the work place. We've gained from the women who were protesting for equal rights in the '60s and '70s. There are so many more women owning private businesses, doing things that they just wouldn't have done twenty, thirty years ago. It's exciting, and I'm in the group that's benefited from that. Women are discovering that they can have a different lifestyle than women were ever allowed to have in society. Maybe that's what's different.

I'm thinking about the beginning of my career, doing cartoons about Hillary Clinton when she became First Lady. There was a lot of argument about her. Is she too uppity? For a lot of women my age, even if you weren't supportive of Hillary as a political figure, you were definitely put out by people saying, "She shouldn't be acting that way. She shouldn't be speaking out." Why? Why? I didn't find anything she said particularly controversial during the first campaign. The whole cookie issue was nonsense.

But that's because—the thing we talked about—she's an aggressive type of woman. That's somehow supposed to be negative. Why? Because she says what she thinks? Because she works? Because she's successful? That's the point that I'm coming from.

I think that's probably why women's rights, women's successes keep showing up in my work. I've worked in private industry, and I've dealt with sexual harassment. I know the different forms it can take. When I watched the Anita Hill hearings, even though I wasn't politically

Detail from
Clinton Legacy, p. 72.

interested at that point, to sit there and hear a group of Senators say, "There is no more sexual harassment. We already took care of that." All I could think, having gone through it myself, was, "you guys are idiots." [Laughs]

I think anything you do in your life comes from something that happened to you previously. Everything contributes to your next phase, to your development. Everything I've done, either artistically or personally or in my business career, has all contributed to where I am now. But the fun part is, you can be a little bit flexible about the doors that are open to you. I've been very fortunate, but I think I've also taken advantage of that. I've said, "Oh, that might be interesting to do" and gone ahead, rather than saying, "I really wanted to do the other thing," but never trying.

HK: In June 2004 you'll have an exhibition of your work at the Library of Congress. People will be looking at your work on the walls, not in a newspaper or on the Internet. What do you want them to take away?

AT: I'm very pleased when people see the subtle points I'm trying to make in a piece of work, if that actually comes across. I try to put different levels into a cartoon. It's a difficult thing to do, and I don't think I'm always successful, but it always pleases me if it works. I also hope people appreciate the quality of the art, the drawings—if it should be appreciated. Are we done?

HK: I think we're done.

AT: Oh, goody.

HK: We covered a lot of good ground.

AT: Okay. Great.

PUT IT ON YOUR TAB

Congressional Budget Office predicts record $480 billion deficit

$350 billion tax cuts questioned

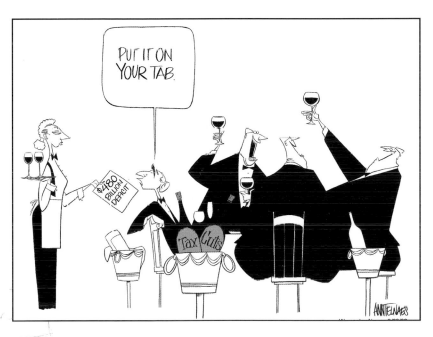

$480 BILLION DEFICIT, 8/28/03
Courtesy of Women's eNews

The nonpartisan Congressional Budget Office released a report on August 26, 2003, predicting a record federal deficit of $480 billion in 2004. They also confirmed that the 2003 deficit would reach $401 billion. The Bush Administration blamed the economy, 9/11, and the increase in defense spending for the deficit, not the $350 billion in tax cuts Congress granted at the president's urging. Many thought that the tax cuts favored the wealthy; Telnaes' cartoon points out that ultimately the American public pays for the economic impact of the deficit and increased spending.

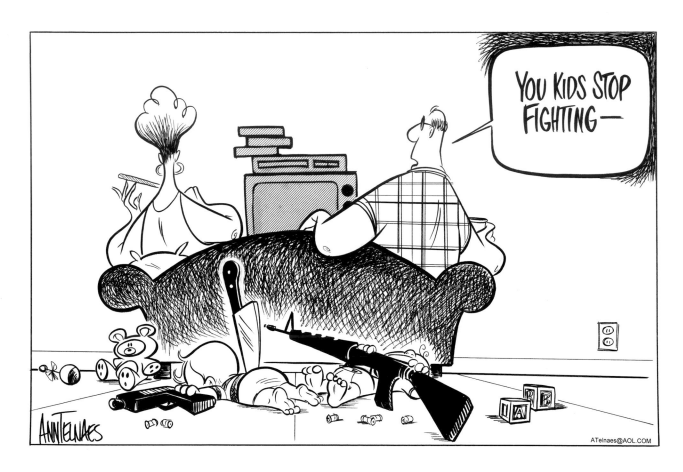

"YOU KIDS STOP FIGHTING," 4/28/96
© Ann Telnaes

One of the subjects that concerns Telnaes is "the availability of guns and violence in American society." She is particularly concerned with the potential for deadly accidents brought about by children's access to weapons. This cartoon predates by three years the gun deaths of fifteen people, including the two teenage shooters, at Colorado's Columbine High School on April 20, 1999. This tragedy brought into sharp relief the issue of gun control.

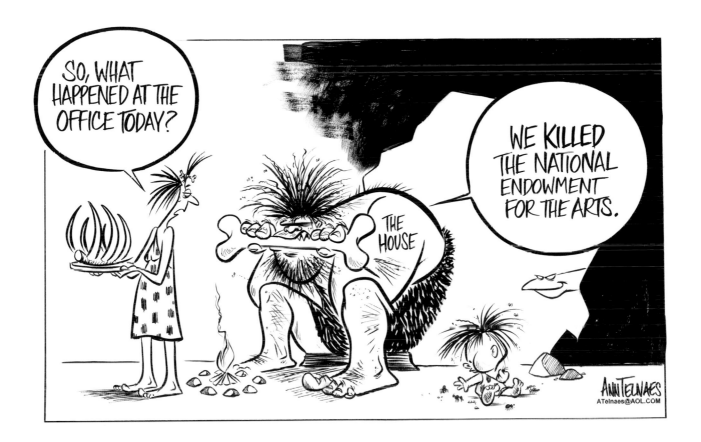

"We killed the National Endowment for the Arts," 7/11/97
© Ann Telnaes

On July 10, 1997, the United States House of Representatives voted by a slim margin to eliminate funding for the National Endowment for the Arts, proposing instead to give block grants to states for schools and local art groups. Political conservatives had opposed NEA support of controversial projects and spending federal money on the arts. On July 23, a Senate panel voted to continue funding the NEA, and ultimately Congress did approve a budget for the agency.

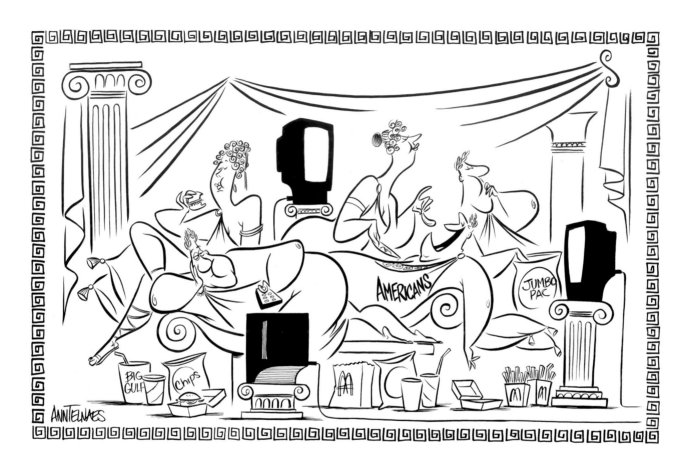

AMERICANS OF THE DECADENCE, 8/9/97
© Ann Telnaes

Telnaes is concerned with overconsumption. "You see it so much in our society," she says. "Just go down to your local Wal-Mart. Americans, in general, use a lot of stuff. Anyone who has done any traveling overseas knows how wasteful we are." Telnaes' rendering of twentieth-century excess lampoons Americans' overconsumption and sedentary lifestyle. Slothful figures who shun exercise recline amid plentiful fast-food containers and multiple televisions in a pseudo-Roman setting. This is an entertaining takeoff on the painting *The Romans of the Decadence,* 1847, by French painter Thomas Couture (1815–1879), which created a stir at the Paris Salon exhibition in 1847.

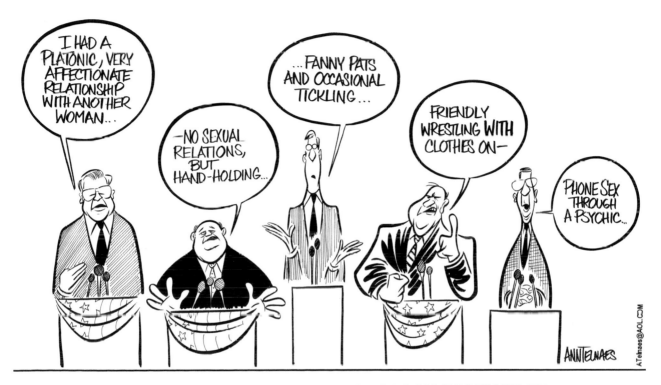

FUTURE CAMPAIGN CONFESSIONS TO LOOK FORWARD TO

FUTURE CAMPAIGN CONFESSIONS TO LOOK FORWARD TO, 2/8/98
© Ann Telnaes

In January 1998, Linda Tripp contacted Kenneth Starr, independent counsel for the Whitewater investigations, about President Bill Clinton's affair with Monica Lewinsky. Although Clinton initially denied the affair, in this cartoon, Telnaes imagines preemptive confessions by political candidates to ward off surprise revelations and scandal. "All of a sudden, people were starting to fess up to things they had done," Telnaes says, "just to make sure it wouldn't get them in trouble in their campaigns later on. And I thought, we're going to get to a point where you have to explain everything you do, even if it's perfectly innocent."

"...THE END IS NOT YET IN SIGHT"
-Ken Starr

ANNTELNAES
ATelnaes@AOL.COM

"...THE END IS NOT YET IN SIGHT," 4/17/98
© Ann Telnaes

On April 16, 1998, Kenneth Starr declined the positions of dean of the School of Law and dean of the School of Public Policy at Pepperdine University. In a letter to Pepperdine's president, Starr explained that he had looked forward to becoming a dean "after completing my duties as Independent Counsel. The work of that Office, however, has expanded considerably, and the end is not yet in sight." As the independent counsel investigating Whitewater, Starr was at the time focusing on whether President Bill Clinton had encouraged Monica Lewinsky to lie about their relationship.

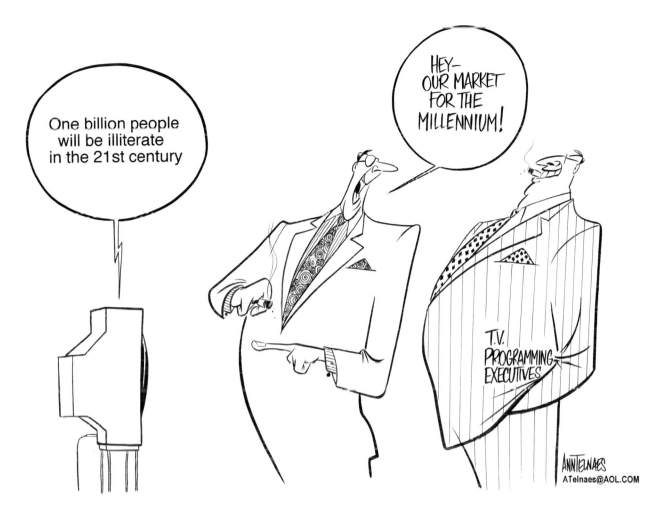

"ONE BILLION PEOPLE WILL BE ILLITERATE IN THE 21ST CENTURY," 12/10/98
© Ann Telnaes

The results of a survey released December 8, 1998 by the United Nations Children's Fund (UNICEF) revealed that nearly 1 billion people would be functionally illiterate in 1999, on the verge of the twenty-first century. This figure included 130 million children, and two-thirds of the illiterate population were women. UNICEF estimated that $7 million per year would be necessary to alleviate the problem, but the television programming executives in Telnaes' cartoon see it as an opportunity for them to make more money.

SIR,
I THINK I FIGURED OUT WHAT THE CLINTON LEGACY IS...

ANNTELNAES

CLINTON LEGACY, 7/7/99
© Ann Telnaes

On July 6, 1999, First Lady Hillary Rodham Clinton filed papers to create an exploratory committee to consider running for the United States Senate in New York state. The possibility that she would be a candidate occurred after the Monica Lewinsky scandal had tarnished Bill Clinton's reputation. At the same time, news stories circulated that Bill Clinton's staff were wondering what his legacy would be. Hillary Clinton was elected to the U.S. Senate in 2000.

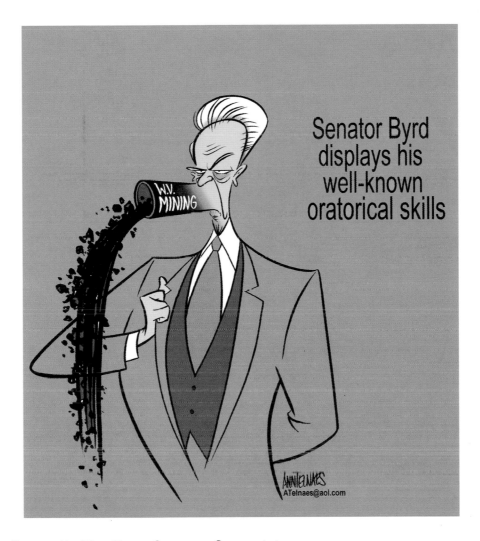

Senator Byrd
displays his
well-known
oratorical skills

W.V.
MINING

ANNTELNAES
ATelnaes@aol.com

SENATOR BYRD DISPLAYS HIS WELL-KNOWN ORATORICAL SKILLS, 11/12/99
© Ann Telnaes

An October 20, 1999, federal court ruling banning mountaintop removal mining in West Virginia prompted West Virginia Senator Robert Byrd to take action to circumvent the ruling. In this type of mining, mountains are blasted to get at low-sulfur coal reserves; the debris is poured into valleys, burying waterways and woodland. Byrd attached a rider to a federal spending bill exempting West Virginia from federal environmental regulations. Byrd persuaded President Bill Clinton to back the rider, but Clinton later withdrew his support.

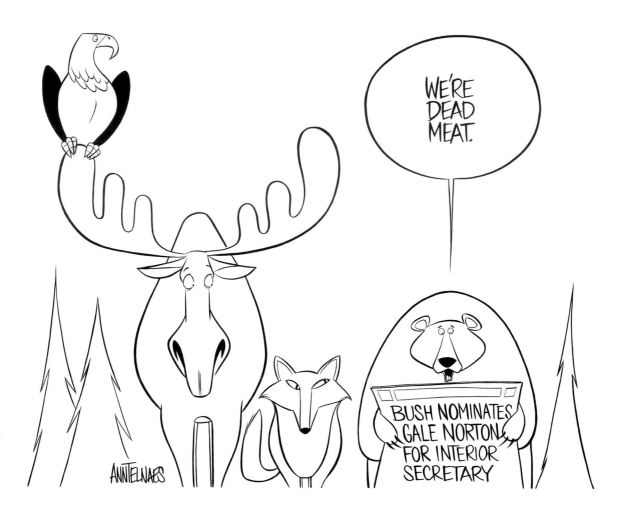

"WE'RE DEAD MEAT," 12/30/00
Courtesy of Tribune Media Services

President George W. Bush appointed Gale Norton, former Colorado attorney general, as secretary of the interior in December 2000. Norton was known to support Bush's proposal that part of Alaska's National Wildlife Refuge be opened to drilling for oil. Critics charged that exploring for oil would damage the environment for animals, including caribou, which prefer to give birth in the area marked for drilling.

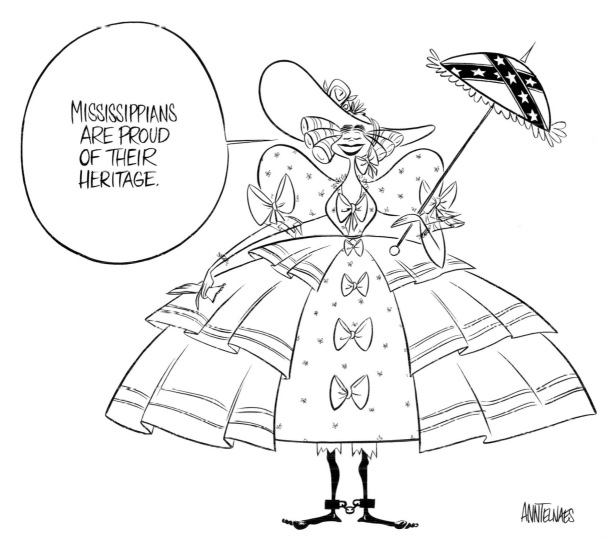

"Mississippians are proud of their heritage," 4/18/01
Courtesy of Tribune Media Services

On April 17, 2001, Mississippians voted nearly 2-1 to keep the Confederate battle flag as part of their state flag. Supporters saw it as a symbol of Southern pride, rather than as a symbol of slavery and as an insult to African Americans. Mississippi is the only state to actually incorporate the Confederate emblem into its flag, although the Alabama and Florida flags are based on the Confederate flag.

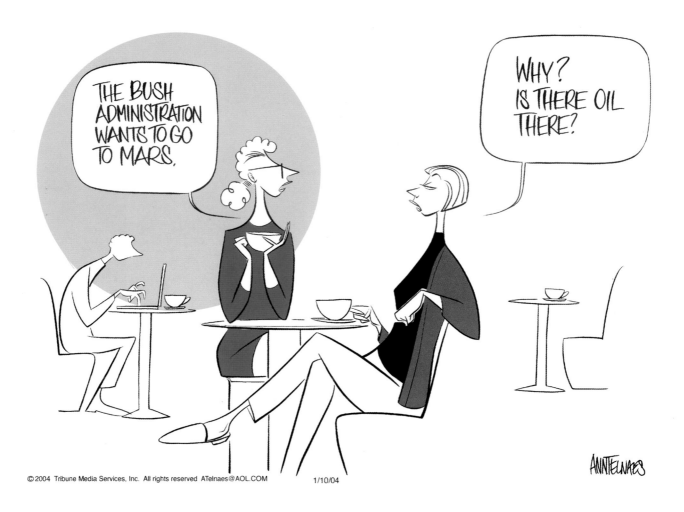

"THE BUSH ADMINISTRATION WANTS TO GO TO MARS," 1/10/04
Courtesy of Tribune Media Services

On January 8, 2004, senior officials in the Bush Administration revealed that President George W. Bush would announce plans for the United States to build a permanent science base on the moon, with the intention of traveling ultimately to Mars. No particulars were given about the cost or how NASA would pay for it. The upbeat plan, announced in an election year, would revitalize the ailing space program and the aerospace industry. Telnaes' cartoon, referring to charges that U.S. foreign policy is heavily influenced by oil, suggests an additional motive.

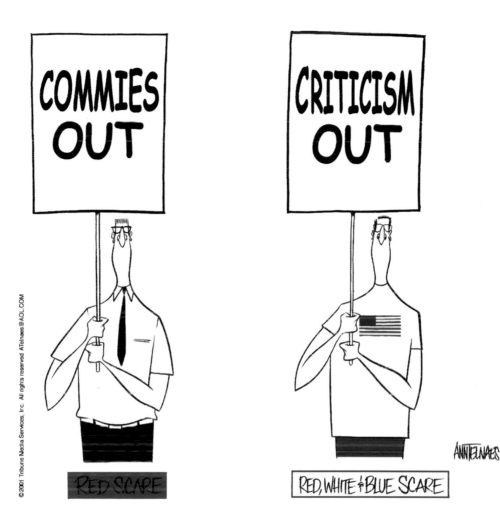

RED SCARE, RED, WHITE & BLUE SCARE, 9/29/01
Courtesy of Tribune Media Services

After the terrorist acts of September 11, 2001, expressions of dissent regarding government policies and actions were widely criticized as unpatriotic. The *Los Angeles Times* reported on September 28, 2001, that public intellectuals were concerned that in a climate of fear and patriotism it would be difficult to carry on the American tradition of questioning, disagreeing with, and challenging government. Telnaes suggests a comparison between repression of dissent springing from the Cold War fear of communism and the current fear of terrorism.

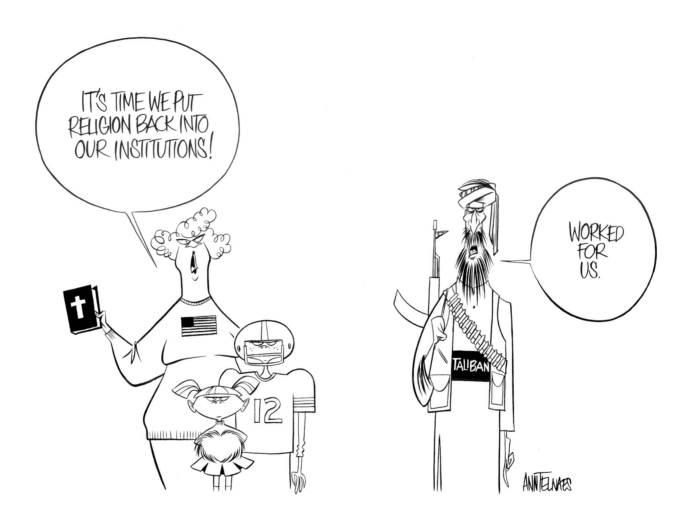

"IT'S TIME WE PUT RELIGION BACK INTO OUR INSTITUTIONS," 10/28/01
Courtesy of Tribune Media Services

Heightened interest in the Taliban's repressive use of religion in ruling Afghanistan gave perspective to Telnaes' ongoing concern with challenges to the separation of church and state. "I strongly believe in the separation of church and state," she says. "People disagree with me and say this country was founded on God and Christian principles, but that's not what I'm talking about. I'm not an atheist. I'm not even an agnostic. But I think that separation of church and state is the best way to protect everyone's right to worship as they choose."

"FOR THE NEW YEAR I'VE DECIDED TO GIVE UP SMOKING, DRINKING, AND MY CIVIL RIGHTS," 12/6/01
Courtesy of Tribune Media Services

On December 4, 2001, Attorney General John Ashcroft told a Senate Judiciary Committee that strong antiterrorism measures were needed to defend the United States, including those that some contended violated civil rights and the Constitution. Among the most controversial measures were plans to monitor conversations between detained suspects and their attorneys and to try those who were not American citizens in military tribunals. Telnaes expected more protest, yet "People seemed to so easily say, we can just give a little bit of our freedom away, to make sure we're all safe," she observed.

"I DON'T RECALL," 5/9/02
Courtesy of Tribune Media Services

Cardinal Bernard Law headed the Catholic Archdiocese of Boston, Massachusetts, during the time that the priest John Geoghan was removed and reassigned to several parishes although accused of sexually molesting boys. On May 8, 2002, Law gave a deposition in a lawsuit brought by eighty-six people who charged that they had been abused. When questioned about events concerning Geoghan, Law frequently replied, "I don't recall." Telnaes draws Law here as the fictional character Pinocchio, whose nose grew longer whenever he lied.

"FBI," 6/25/02
Courtesy of Tribune Media Services

This cartoon takes aim at Section 215 of the USA Patriot Act, which allows federal agents to demand a person's library and book-store records in the interests of national security. Critics charged such action was a violation of civil liberties. The girl in the cartoon, who is holding a copy of *1001 Arabian Nights*, is being questioned by the FBI. "Librarians were great during that time," says Telnaes, "because they actively protested giving up their records."

I PLEDGE ALLEGIANCE TO THE FLAG OF THE UNITED STATES OF AMERICA, AND TO THE POLITICAL POSTURING FOR WHICH I STAND, THE CONGRESS, USING GOD, IGNORING ISSUES, MANIPULATING AND MISLEADING YOU ALL.

Lieberman 2004

ANNTELNAES

"I PLEDGE ALLEGIANCE TO THE FLAG . . . ," 6/27/02
Courtesy of Tribune Media Services

On June 25, 2002, the Ninth Circuit federal court of appeals ruled that saying the Pledge of Allegiance in public schools violated the Constitution because the pledge included the phrase "under God." The following morning nearly every senator appeared at a prayer service in which Senate chaplain Lloyd Ogilvie declared that "there is no separation between God and the state." Senator Joseph Lieberman was among those calling for a constitutional amendment to retain "under God" in the pledge. Also on June 26, the federal appeals court decided to put its ruling on hold.

Silence

THE APPROPRIATE SEPT 11TH REMEMBRANCE

THE APPROPRIATE SEPT IITH REMEMBRANCE, 9/5/02
Courtesy of Tribune Media Services

"This country is very interesting when it comes to catastrophes," says Telnaes. "The news coverage of tragedies is sickening. I thought the year anniversary of 9/11 was going to be awful. In Israel, they remember the tremendous tragedy of the Holocaust differently. They have a long horn sound, and wherever you are, if you're in the streets, if you're in your car, anywhere you are, you just stop. You're quiet for a minute. And I thought, this is perfect, this is what we ought to do."

REPORT SHOWS AMERICANS ARE "LIVING" LONGER, 9/13/02
Courtesy of Tribune Media Services

The National Center for Health Statistics at the Centers for Disease Control and Prevention issued a report in September 2002 stating that "in 2000, Americans enjoyed the longest life expectancy in U.S. history—almost 77 years." The report also pointed out that 61 percent of adults were overweight and 27 percent obese, the result of overeating and lack of exercise. Overweight and obesity were both factors in poor health.

SUPERSIZING, 2/19/03
Courtesy of Women's eNews

The *New England Journal of Medicine* reported in February 2003 that research indicated that overweight and obesity were factors in 20 percent of women's deaths from cancer; breast cancer was one type cited. Heart disease has also been linked to obesity and overweight. Yet supersized portions and two-for-one value meals are featured at fast-food restaurants.

THE FCC LADY SINGS, 6/2/03
Courtesy of Tribune Media Services

On June 2, 2003, the Federal Communications Commission revised broadcasting rules to allow a single company to own television stations reaching 45 percent of households, as well as newspapers, television, and radio stations in the same city. Critics charged that these rules would create monopolies with control over news and entertainment. Telnaes shows the three types of media—print/radio/television—in this cartoon. She uses newspaper print to create the skirt pattern for the "fat lady," whose singing signals the end of competition. A story about the FCC decision printed on a peachy pink paper in *The Financial Times* provided a lovely color for the cartoon.

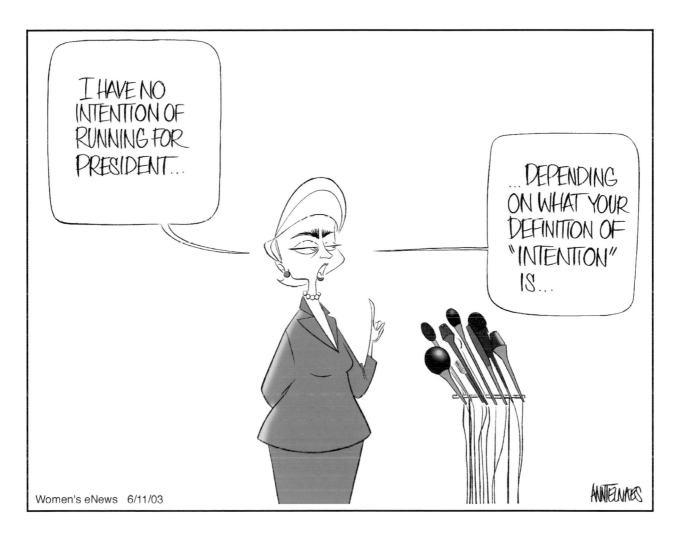

HILLARY IN 2008, 6/11/03
Courtesy of Women's eNews

In the publicity surrounding the release of Hillary Clinton's autobiography on June 9, 2003, the former first lady and senator was asked by *Time* magazine and ABC's Barbara Walters whether she wanted to run for president in 2008. Clinton answered, "I have no intention of running for president." Telnaes plays on the previously publicized response of her husband, former president Bill Clinton, when asked whether he had had an affair with Monica Lewinsky: "It depends on what the definition of is, is."

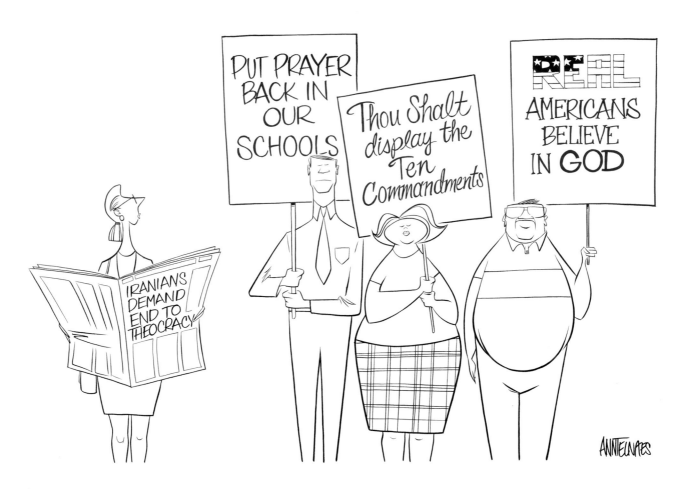

IRANIANS DEMAND AN END TO THEOCRACY, 6/20/03
Courtesy of Tribune Media Services

In June 2003, the Islamic Association, a national student organization in Iran, met to discuss ending the theocracy, established in 1979, that governs their country. They issued a statement in favor of the right to criticize government, and declared the holding of absolute power "heresy." At the same time, an Alabama federal appeals court held hearings to decide whether it was constitutional for a monument of the Ten Commandments to be displayed in a state judicial building. Telnaes highlights the irony as she compares these situations. Issues regarding the separation of church and state, such as whether prayer should be allowed in public schools, continue to be debated and tested in court cases in the United States.

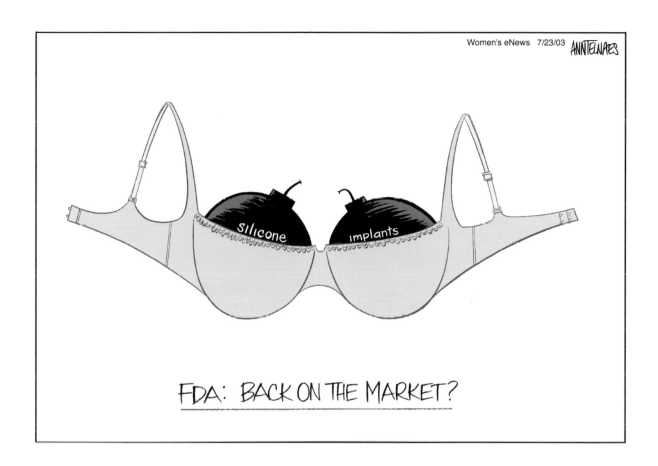

Courtesy of Women's eNews

SILICONE IMPLANTS, 7/22/03

On July 21, 2003, the National Organization for Women (NOW), Public Citizen, and other consumer and health groups asked the federal Food and Drug Administration to delay reviewing applications to market silicone breast implants because of long-term health risks. They argued that only clinical trials of seven to ten years' duration would provide enough information about the impact of the implants on women's health; the FDA felt that two years of clinical trials were sufficient. Silicone implants were banned in 1992 after the FDA had received increasing complaints about the problems that they allegedly caused. In October 2003, an FDA advisory committee recommended that they be allowed back on the market.

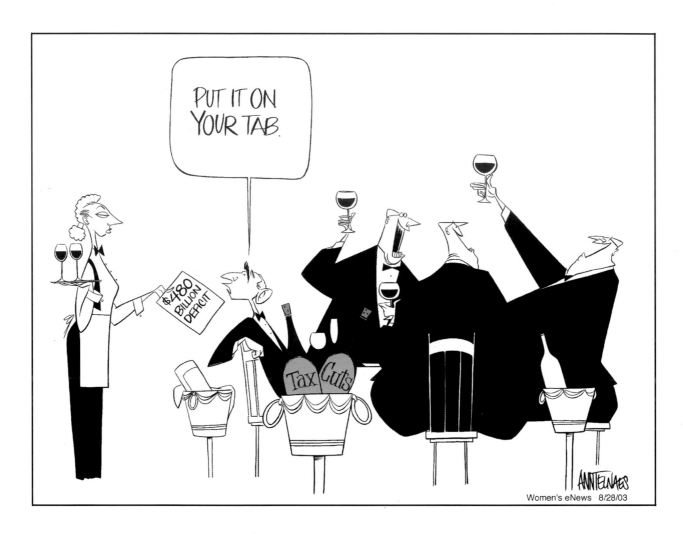

$480 BILLION DEFICIT, 8/28/03
Courtesy of Women's eNews

The nonpartisan Congressional Budget Office released a report on August 26, 2003, predicting a record federal deficit of $480 billion in 2004. They also confirmed that the 2003 deficit would reach $401 billion. The Bush Administration blamed the economy, 9/11, and the increase in defense spending for the deficit, not the $350 billion in tax cuts Congress granted at the president's urging. Many felt that the tax cuts favored the wealthy; Telnaes' cartoon points out that ultimately the American public pays for the economic impact of the deficit and increased spending.

Born Again
Feminist

BORN AGAIN FEMINIST, 10/07/03
Courtesy of Tribune Media Services

While Arnold Schwarzenegger was running for governor of California in the recall election on October 7, 2003, six women accused him of sexual harassment. After denying the charges, Schwarzenegger admitted that "It is true that I was on rowdy movie sets and I have done things that were not right . . . to those people I have offended, I want to say to them that I'm deeply sorry. . . ." He later stated that "I want to prove to the women that I will be a champion of the women." More women subsequently came forward to say that Schwarzenegger had groped or harassed them. Schwarzenegger won the gubernatorial election.

DEAN, THE MOUTH WILL RISE AGAIN, 11/4/03
Courtesy of Tribune Media Services

Howard Dean, contender for the 2004 Democratic presidential nomination, drew criticism from fellow Democrats for declaring in an interview that he wanted to be "the candidate for guys with Confederate flags in their pickup trucks." He drew further criticism for favoring state regulation of guns and opposing stronger federal gun control. In defending himself, Dean called the Confederate flag "a loathsome symbol," but argued that "we have to reach out to all disenfranchised people," such as disaffected voters in the South.

THE "PARTIAL BIRTH ABORTION" BAN SIGNING CEREMONY

The "Partial Birth Abortion" Ban Signing Ceremony, 11/6/03
Courtesy of Tribune Media Services

On November 5, 2003, President George W. Bush signed into law a ban on partial birth abortion, a rarely used procedure performed on women during pregnancies that have advanced beyond eighteen to twenty weeks. The president signed the bill surrounded by smiling men, including Jerry Falwell, Attorney General John Ashcroft, and Senator George Allen. No women appeared in the widely distributed photograph of the signing. "The situation is so absurd that you don't have to do much," says Telnaes. "You're just showing what everyone who looks at the photo is thinking."

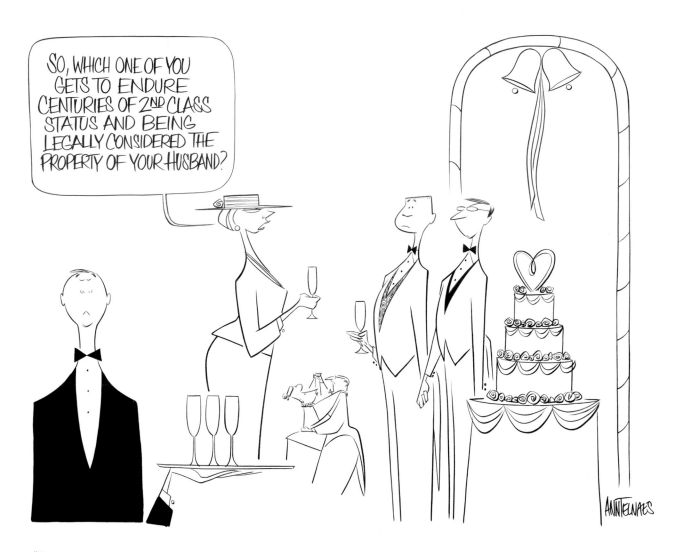

"So, which of you gets to endure centuries of 2nd class status and being legally considered the property of your husband?", 11/21/03
Courtesy of Tribune Media Services

The highest court in Massachusetts ruled on November 18, 2003, that gay couples have the right to marry, according to the state constitution. The ruling stated that "the Massachusetts Constitution affirms the dignity and equality of all individuals. It forbids the creation of second-class citizens." Telnaes' cartoon points out that the traditional view of marriage between a man and a woman left plenty of room for second-class citizenship.

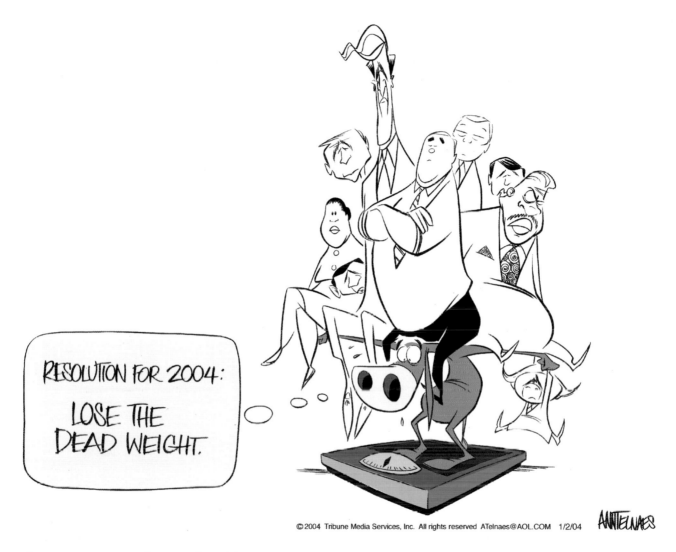

RESOLUTION FOR 2004: LOSE THE DEAD WEIGHT.

RESOLUTION FOR 2004: LOSE THE DEAD WEIGHT, 01/2/04
Courtesy of Tribune Media Services

With ten months to go until the 2004 presidential elections, nine Democratic contenders were vying for their party's nomination: Carol Moseley Braun, Wesley Clark, Howard Dean, John Edwards, Dick Gephardt, John Kerry, Dennis Kucinich, Joe Lieberman, and Al Sharpton. The New Year's resolution expressed in Telnaes' cartoon was to trim down the field to a manageable size. Braun and Gephardt dropped out of the race later in January.

THE WORLD ACCORDING TO W

... Is AN IMMEDIATE THREAT TO AMERICANS ... HAS TIES TO AL QAIDA ...
HAS WEAPONS OF MASS DESTRUCTION ..., 5/29/03
Courtesy of Tribune Media Services

President George W. Bush persuaded many Americans of the need to go to war
with Iraq by repeating that Iraq had ties to Al Qaida and weapons of mass
destruction (WMDs). In May 2003, the Program on International Policy Attitudes
found that 41 percent of Americans polled believed that the United States had
found WMDs, or were unsure if they had; 31 percent believed that Iraq had used
chemical or biological weapons during the war, or were unsure; 60 percent con-
sidered the weapons the main reason to invade Iraq. No weapons of mass
destruction have been found as of February 2004.

Many Americans believe WMDs found

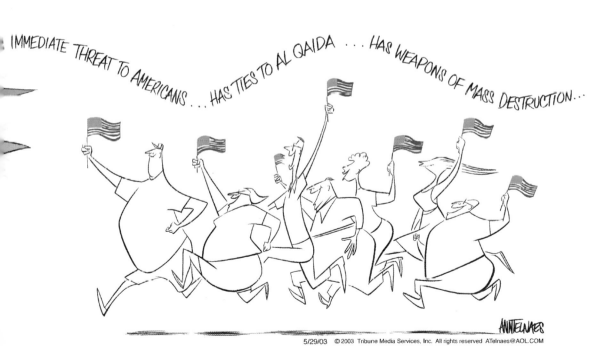

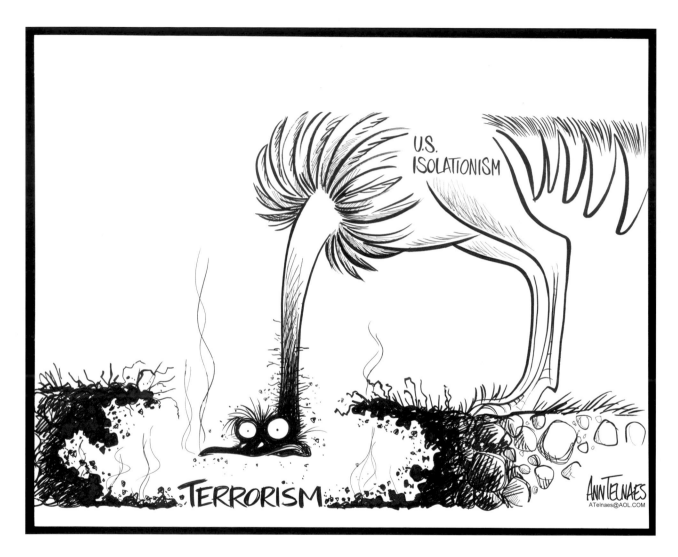

U.S. ISOLATIONISM, 7/27/96
© Ann Telnaes

Americans' sense of security was shattered after the breakup of TWA Flight 800 on July 17, 1996 (later determined to be an accident caused by poor fuel tank design) and the July 27 explosion of a homemade pipe bomb at the Olympic Games in Atlanta, Georgia. Although many Americans felt that they could isolate themselves from international politics and issues, these events brought the vulnerability of U.S. citizens into sharp relief, and made it clear that no country can ignore or remain untouched by terrorism.

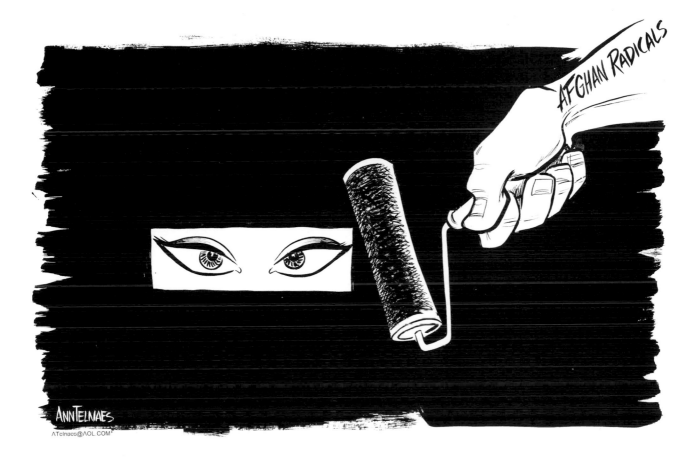

AFGHAN RADICALS, 10/10/96
© Ann Telnaes

On September 27, 1996, radical Islamic rebels ousted the existing Afghan government. This Taliban regime immediately banned women and girls from work and from school. Women were required to be accompanied by a male relative in public and were compelled to wear the burka—a garment that concealed them completely, shielding even their eyes with cloth mesh. "This was the first cartoon I ever did about the Taliban and their treatment of women," Telnaes says. "I didn't even know they were called the Taliban—I just put 'Afghan Radicals,' a nice, all-purpose term. I thought, 'let's have them pulling a roller over a face, so the women disappear figuratively and literally.'"

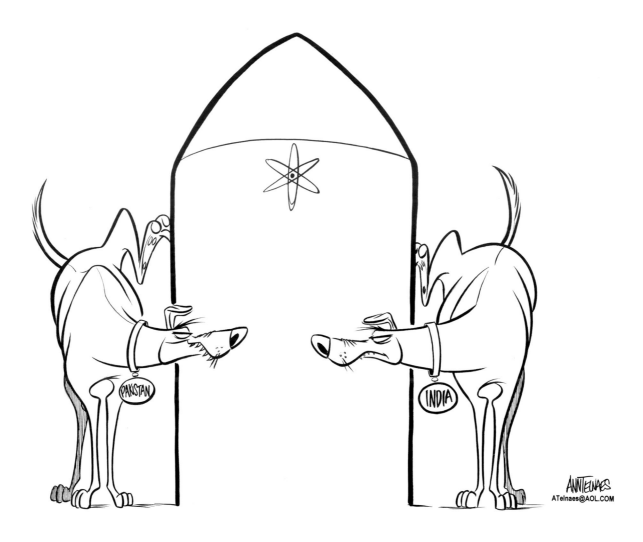

PAKISTAN AND INDIA BEHAVING AS DOGS OVER NUCLEAR POWER, 5/28/98
© Ann Telnaes

Tensions between India and Pakistan rose after India's prime minister announced three nuclear tests on May 12, 1998. Hints that India not only had nuclear capability, but was also preparing missiles with nuclear warheads, prompted Pakistan to carry out its own nuclear tests on May 28, 1998—nudging these countries ever closer to serious conflict. Telnaes draws them as two dogs. "Being a dog owner, and a woman, you notice how male dogs tend to visit the same spot and mark their territory," says Telnaes. "The India-Pakistan affair reminded me of that."

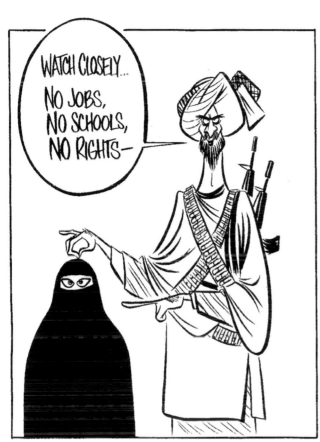
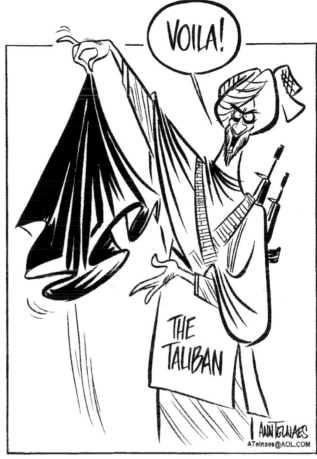

"Watch closely . . . No jobs, no schools, no rights," 6/21/98
© Ann Telnaes

The 1996 takeover of Afghanistan by the conservative Islamic Taliban placed severe limitations on women, who were forced to stay inside the home and to forgo work and school. Hospitals for women were frequently understaffed, and women could not receive treatment unless they wore a burka and were accompanied by a male relative. The new laws caused both international protest and a sharp decline in the physical and mental health of Afghan women, as they were condemned to near obscurity by their own government.

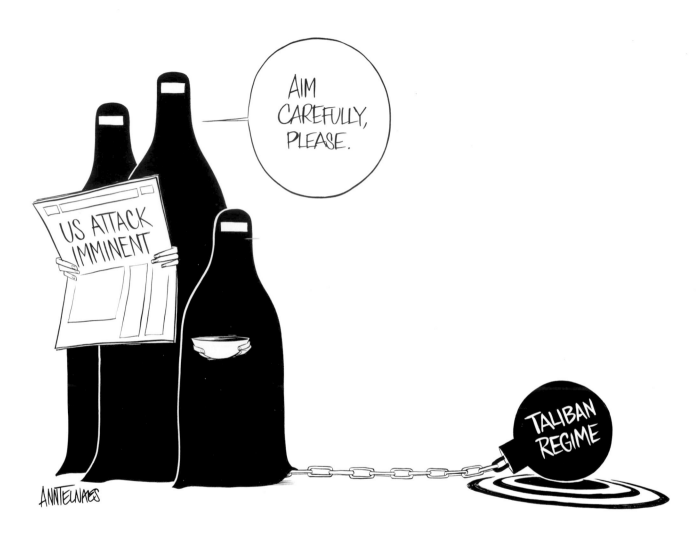

"AIM CAREFULLY, PLEASE," 10/2/01
Courtesy of Tribune Media Services

By October 2, 2001, U.S. forces were gathering near the Arabian Sea in preparation for an attack on Afghanistan. The United States and Britain began military air strikes against Afghanistan on October 7, hitting the Taliban national headquarters and the Kandahar airport. Representatives from fifty-six Islamic nations attending an emergency meeting in New York raised concerns about civilian casualties, although they did not directly denounce military action against the Taliban. Telnaes' cartoon addresses the particular vulnerability of women. "At the time I was thinking, just be careful where you're aiming those bombs," she says.

"THIS IS SO RESTRICTIVE AND UNCOMFORTABLE; AND I'M FORCED TO WEAR IT
BECAUSE OF MISGUIDED, FANATICAL RELIGIOUS THINKING BY SOME PEOPLE," 10/5/01
Courtesy of Tribune Media Services

On October 2, 2001, Robert Stevens, an employee at American Media, became the first victim to be hospitalized from the inhalation of anthrax; he died on October 5. Fear of anthrax heightened as more people tested positive. Worries about biological and chemical warfare prompted many Americans to take protective measures, including buying gas masks. While a man complains in this cartoon, the woman reminds us about restrictions that women endured under the Taliban. "Can you imagine if there were a country that said all men are not allowed to leave their homes or go to school, what people would say?" asks Telnaes.

SAUDI RESPONSE TO ISLAMIC RADICALISM

SAUDI RESPONSE TO ISLAMIC RADICALISM, 12/27/01
Courtesy of Tribune Media Services

Although the government of Saudi Arabia cut ties with the Taliban after the 9/11 attacks on the United States, the regime came under fire for not doing more to prevent international terrorism. Furthermore, fifteen of the nineteen hijackers on 9/11 were Saudi nationals. As the United States focused attention on Afghanistan and Iraq, some people raised questions about Saudi Arabia's hands-off approach and its role in terrorism: the government had looked the other way as its citizens joined militant Islamic organizations in other countries, and it allegedly ignored the financing of terrorism by private parties. "I thought, shouldn't this be something that should be looked at," says Telnaes, "rather than stopping every single Pakistani and African person who comes through our airports?"

MILOSEVIC WRESTLES WITH HIS CONSCIENCE

MILOSEVIC WRESTLES WITH HIS CONSCIENCE, 2/12/02
Courtesy of Tribune Media Services

On February 12, 2002, Slobodan Milosevic, former leader of Serbia and Yugoslavia, became the first head of state to stand trial for war crimes. He was accused of breaking the Geneva Convention, genocide, and general crimes against humanity during wars in Bosnia, Croatia, and Kosovo throughout the 1990s. Milosevic maintained that his trial was an "evil and hostile attack," and illegal, intended to justify the actions of NATO, which bombed Yugoslavia in 1999. In this caricature, Telnaes plays on the image of an angel and devil giving competing advice to the conscience—Milosevic hears nothing but devils.

KING MUGABE, 2/7/02
Courtesy of Tribune Media Services

Robert Mugabe, Zimbabwe's leader since 1980, conducted an often-violent scare-tactic campaign in the months leading up to his reelection in March 2002. The democracy of the election was questioned, since Mugabe had forced European Union election monitors to leave, enacted laws forbidding demonstrations, banned foreign journalists, and accused his opponent, Morgan Tsvangirai, of an assassination attempt. Mugabe seemed most concerned with maintaining his own power and control, even though Zimbabwean citizens were suffering from severe food shortages—a problem he largely ignored throughout the campaign.

MAN OF A MISSING PIECE, 4/20/02
Courtesy of Tribune Media Services

Sparked by the March 27, 2002, Palestinian suicide bombing that claimed twenty-six Israeli civilians, Israeli Prime Minister Ariel Sharon authorized military occupation of several Palestinian cities. Violence erupted, with Israeli troops imposing detentions and curfews in the West Bank, trapping Palestinian leader Yasser Arafat inside his compound and threatening him with exile. On April 7, President Bush urged Sharon to withdraw his forces "without delay." However, Israeli troops still had not withdrawn over a week later, and on April 18, Bush reneged on his firm stance, calling Sharon "a man of peace."

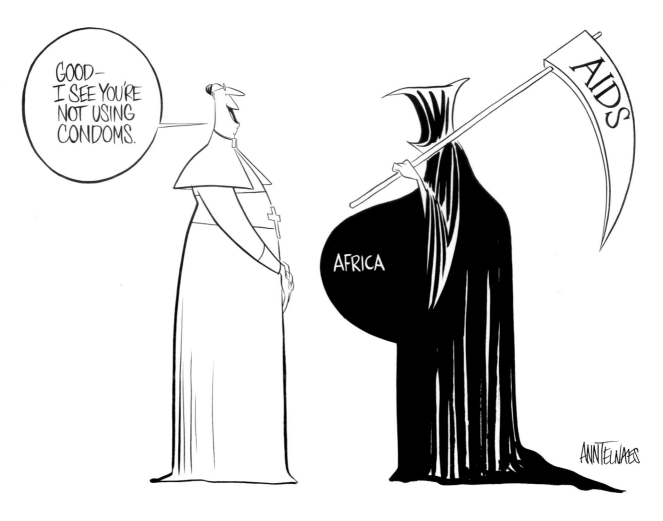

"Good—I see you're not using condoms," 7/5/02
Courtesy of Tribune Media Services

"One of my recurring themes is the issue about reproductive rights and the spread of AIDS in Africa," says Telnaes. "But institutions like the Vatican don't condone condom use." The Catholic Church claims that only abstinence will provide protection against HIV and AIDS and that the distribution of condoms encourages promiscuity. Although there is ample scientific evidence that correct use of condoms reduces one's risk of contracting HIV and other sexually transmitted diseases, the church continues to oppose their use. "I'm not talking about Catholicism here, I'm talking about policies," Telnaes says.

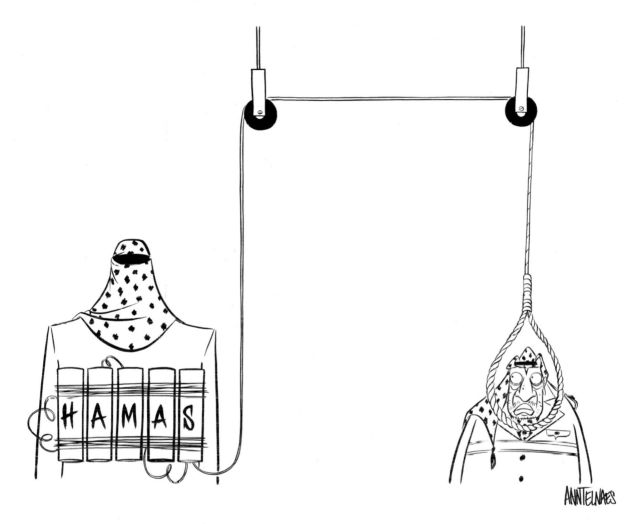

ARAFAT IN HANGMAN'S NOOSE YOKED WITH HAMAS, 8/4/02
Courtesy of Tribune Media Services

On August 4, 2002, suicide bombings perpetrated by the fundamentalist Islamic group Hamas claimed the lives of eighteen people in the Israel/Palestine region; dozens more were wounded. The Israeli government blamed Palestinian leader Yasser Arafat for the violence, faulting him for allowing Hamas to get out of control. Some claimed that Arafat tolerated the tactics of Hamas because acts of violence brought attention to the Palestinian cause, even though the violent and strongly religious Hamas is Arafat's rival for power—the group challenges his attempt to create a secular and unified government for a Palestinian state.

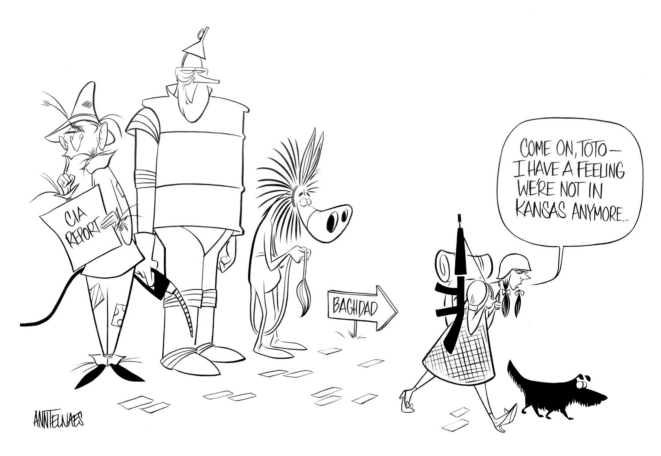

"Come on, Toto, I have a feeling we're not in Kansas anymore," 10/14/02
Courtesy of Tribune Media Services

An October 4, 2002, CIA report alleging that Iraq could (but might not) have a nuclear weapon in the next decade was used by President Bush and Vice President Dick Cheney to strengthen justification for a U.S. invasion of Iraq. They quickly received congressional backing from both Republicans and Democrats for the invasion. In mid-October, the Bush Administration presented an ultimatum to the United Nations, making it clear that without UN support, they would take unilateral action. Telnaes' cartoon spoofs *The Wizard of Oz* to show that the United States was already "on its way" to Iraq.

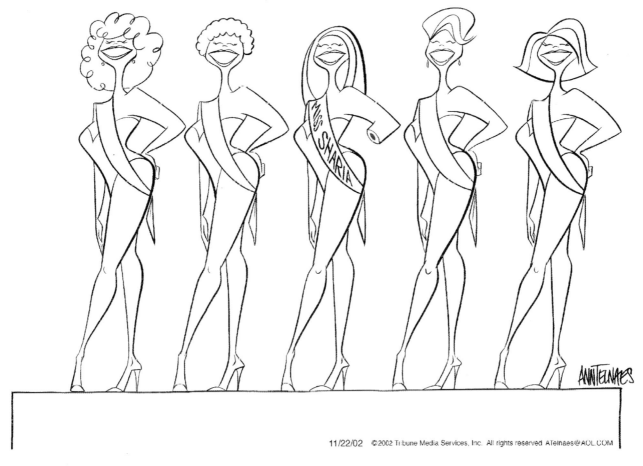

MISS SHARIA, 11/22/02
Courtesy of Tribune Media Services

The fifty-second Miss World beauty pageant, set to be hosted by Nigeria on December 7, 2002, immediately encountered disapproval from conservative Muslims, who claimed that the contest promoted immorality. Several beauty pageant contestants were also boycotting the event, protesting the harsh form of Sharia law practiced in parts of Nigeria: recent Sharia court sentences included amputations of limbs as punishment for theft and stonings of women who delivered children outside of marriage. A November 16 newspaper article about the competition sparked riots in which over 500 people were injured and more than 100 killed; the pageant was moved to London.

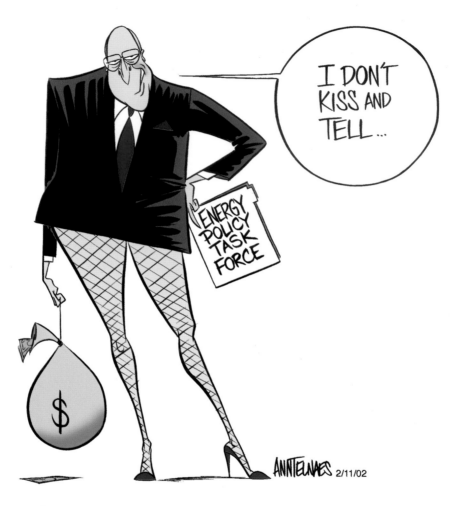

"I DON'T KISS AND TELL," 2/11/02

©Ann Telnaes. For reprint contact www.cartoonistgroup.com

In 2001, Vice President Cheney led an energy task force to determine the Bush Administration's national energy policy. Its conclusions were questioned after the Chapter II bankruptcy of Enron—an energy broker that had held several meetings with Cheney and members of his staff. Cheney refused to release details of the meetings or the names of those involved. He argued that the administration had a constitutional right to keep those records secret because the meetings were instrumental in developing national policy. A federal judge agreed with Cheney in December 2002, but the Supreme Court agreed to hear the case on appeal.

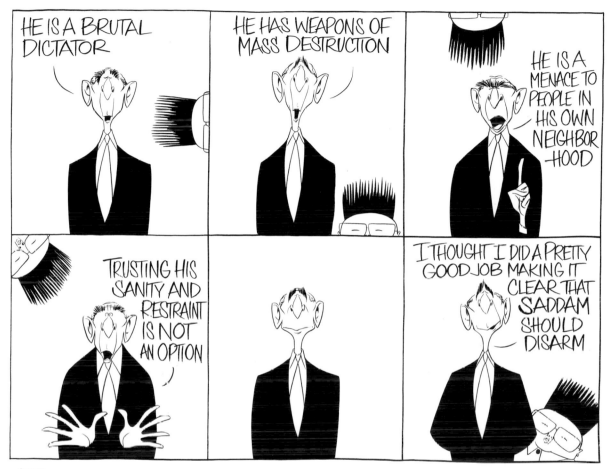

"HE IS A BRUTAL DICTATOR," 2/3/03
Courtesy of Tribune Media Services

In his 2003 State of the Union address, President Bush accused Saddam Hussein of possessing weapons of mass destruction. Saddam was painted as a dangerous dictator whose "sanity and restraint" could not be trusted. (The four other panels in Telnaes' cartoon also include actual Bush quotations about Hussein.) In the same speech, the behavior of Kim Jong II of North Korea was brushed over. Jong had controlled a Stalinist regime since 1994 and announced in October 2002 that his country was developing a nuclear arms program; in December 2002, United Nations inspectors were dismissed from the country, and he withdrew from the Nuclear Nonproliferation Treaty.

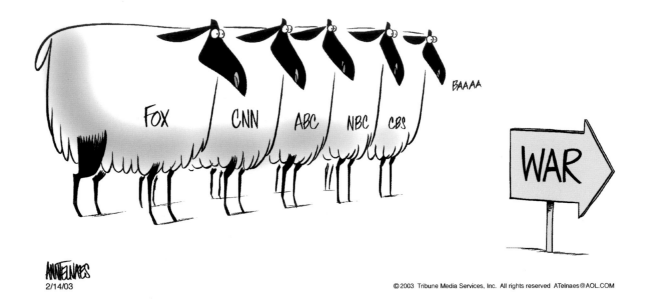

NETWORK SHEEP AND WAR, 2/14/03
Courtesy of Tribune Media Services

Telnaes' cartoon criticizes television network coverage during the war in Iraq. "All the major television media outlets—Fox, CNN, ABC, NBC, CBS—didn't do a lot of questioning about why we were really going to war," she says. "They are now, some of them, but they should have done it before the fact. They have a responsibility to the American public. So I portrayed them as sheep, a very recognizable image. If you're a sheep, you just follow the herd without thinking."

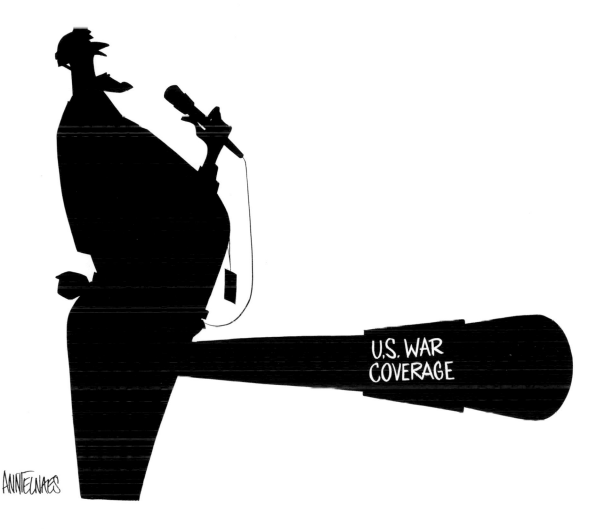

U.S. WAR COVERAGE, 4/1/03
Courtesy of Tribune Media Services

"I felt, as many Americans felt, that television coverage about Iraq was very slanted toward being pro-war," says Telnaes. "There were a lot of stories that kind of glamorized going to war, the machismo of it. I drew the large microphone to show that television coverage here was very macho, which might reflect the fact that mostly men are in charge of that medium. I didn't see many stories about Iraqi families who were on the receiving end of all this. They could have at least shown the effects our actions were having."

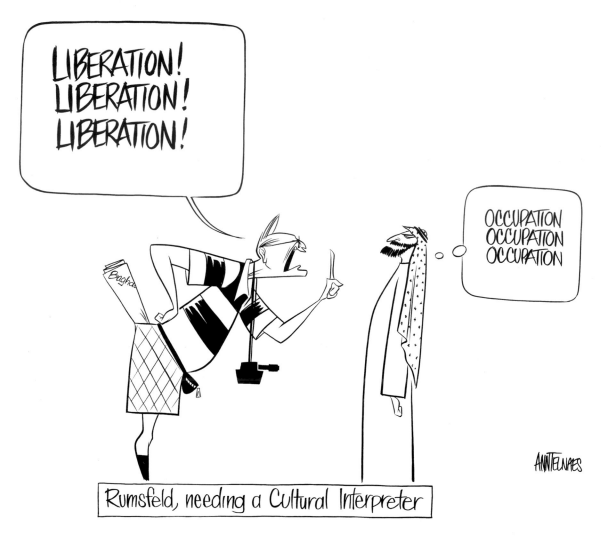

RUMSFELD, NEEDING A CULTURAL INTERPRETER, 4/3/03
Courtesy of Tribune Media Services

"Operation Iraqi Freedom" commenced on March 20, 2003; the Bush Administration billed the war at home as one promoting liberty and democracy, and distributed propaganda in Iraq portraying Americans as liberators—not as an army of occupation. International debate raged about the difference between liberation and occupation, and left Defense Secretary Donald Rumsfeld scrambling to defend his strategy. In an April 1 speech, Bush stated: "We are coming with a mighty force to end the reign of your oppressors," but not all Iraqis welcomed their "liberators," as American troops faced surprisingly bitter resistance.

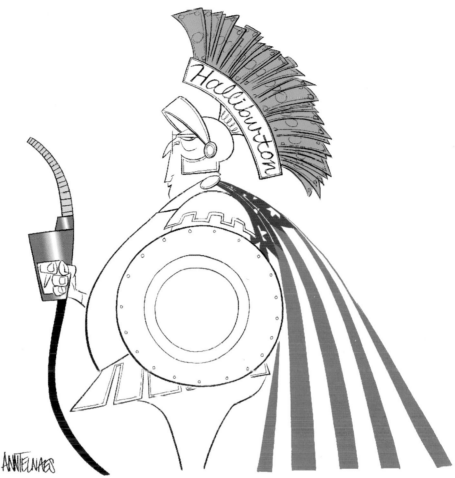

CHENEY AS HALLIBURTON ROMAN WARRIOR, 5/7/03
Courtesy of Tribune Media Services

After the war in Iraq began, Halliburton, an oil company with ties to Vice President Dick Cheney, received a $7 billion noncompetitive contract for work in Iraq. In early May 2003, the U.S. Army revealed that the scope of work was significantly greater than initially disclosed. "This cartoon is about how Halliburton and other companies make money from having a war go on," says Telnaes. "And Cheney, who is connected to this company, is in a position to influence whether we go to war." Cheney appears as a Roman warrior, recalling an empire that frequently engaged in conflict and expansion.

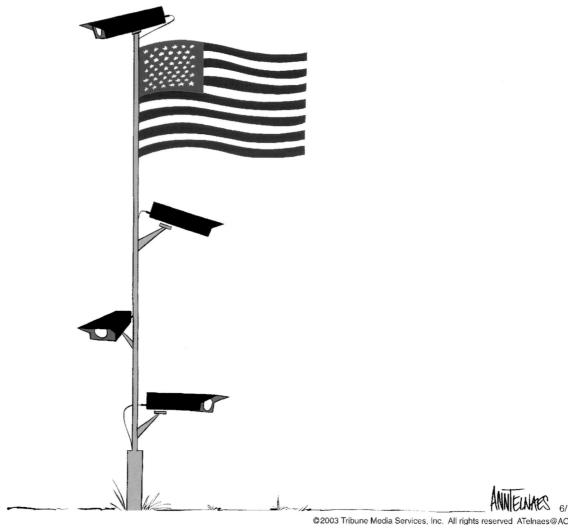

ANNTELNAES 6/13/03

PATRIOTIC SURVEILLANCE, 6/13/03
Courtesy of Tribune Media Services

Telnaes drew this cartoon on the eve of Flag Day, a traditional celebration in the United States. In the post-9/11 United States, this flag is surrounded by cameras, indicating the Bush Administration's preoccupation with surveillance, defended as patriotism even when it infringes on civil liberties.

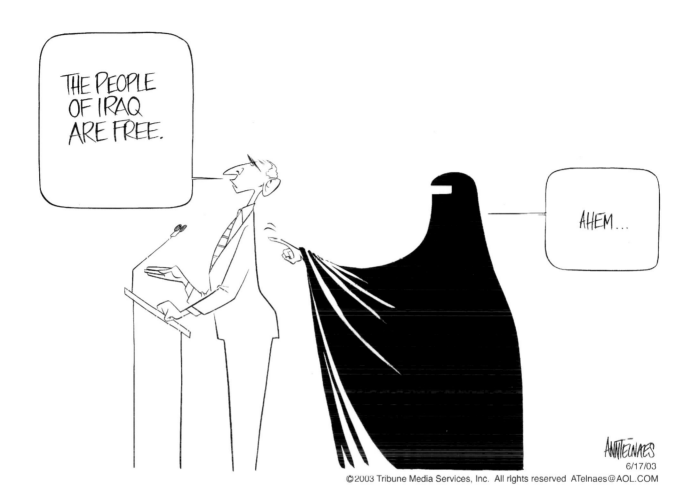

"THE PEOPLE OF IRAQ ARE FREE," 6/17/03
Courtesy of Tribune Media Services

While making remarks at a community college in Virginia on June 17, 2003, President Bush observed that with Saddam Hussein removed from power, "the people of Iraq are free." However, under Hussein's Baath Party rule, women in Iraq had relative freedom. In the wake of Hussein's fallen government, conservative Islamic religious organizations were waiting to rush in and fill the void—creating concerns about just how much equality and freedom the women of Iraq would enjoy.

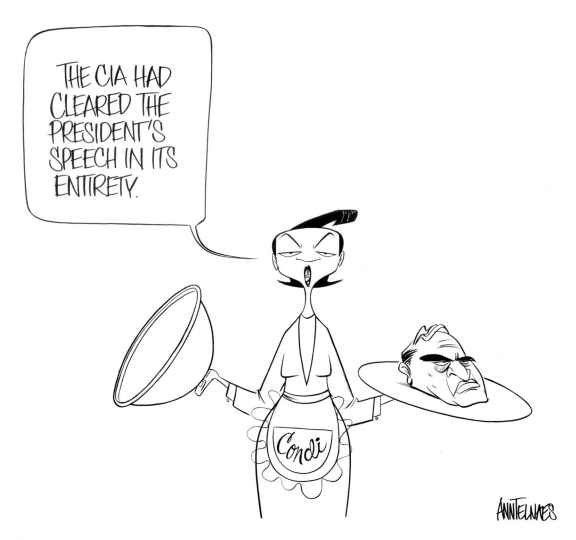

"THE CIA HAD CLEARED THE PRESIDENT'S SPEECH IN ITS ENTIRETY," 7/11/03
Courtesy of Tribune Media Services

A key piece of information used in Bush's 2003 State of the Union address to support the U.S. attack on Iraq—that Iraq was attempting to obtain uranium from Africa—was proved to be based on forged documents. The Bush Administration was accused of distorting facts to convince Americans to go to war. On July 11, national security adviser Condoleezza Rice defended the president, insisting that "the CIA cleared the speech in its entirety." Later that day, CIA Director George Tenet took responsibility for the intelligence. In this cartoon, Rice displays his head on a platter, as did Salome with the head of John the Baptist.

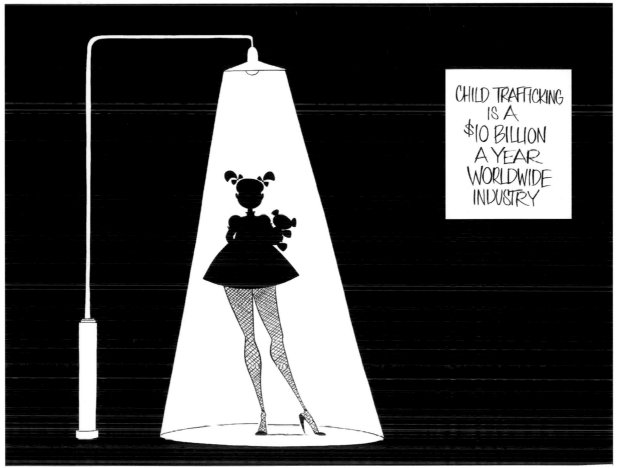

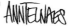

CHILD TRAFFICKING IS A $10 BILLION A YEAR WORLDWIDE INDUSTRY, 8/14/03
Courtesy of Tribune Media Services

The British branch of UNICEF released a report on July 18, 2003, titled "Stop the Traffic," revealing a rise in worldwide child trafficking and calling for improved laws and increased vigilance to combat child exploitation. According to UN statistics, about 1.2 million children ranging in age from four months to eighteen years are coerced, abducted, or sold from a variety of countries—the majority from Asia and Africa—netting around $10 billion in profits. Many of the children's captors see child trafficking as less risky than other crime, largely because of nonexistent preventative laws and loopholes.

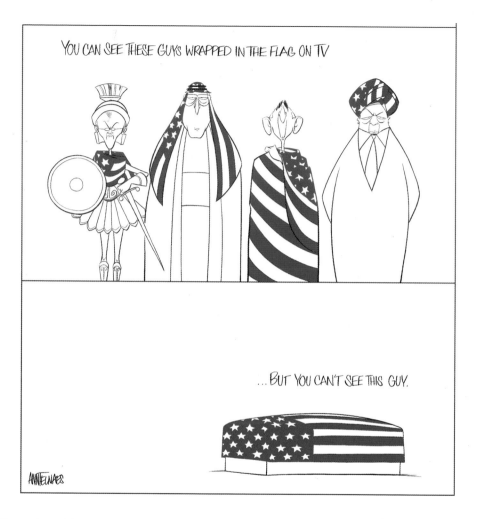

YOU CAN SEE THESE GUYS WRAPPED IN THE FLAG ON TV ... BUT YOU CAN'T SEE THIS GUY, 10/23/03
Courtesy of Tribune Media Services

In this cartoon, Defense Secretary Donald Rumsfeld, Vice President Dick Cheney, President Bush, and Attorney General John Ashcroft are patriotically swathed in the American flag. The Bush Administration publicly extolled its success in Iraq; but an October 16 memo from Rumsfeld leaked to *USA Today* questioned, "Are we winning or losing the Global War on Terror?" Because of this memo and a policy that strictly banned media coverage of dead American soldiers returning to the United States in body bags, the administration was suspected of manipulating public opinion. Nearly 350 military personnel had died in the Iraq conflict by October 23.

"I looked the man in the eye.
I was able to get a sense of
his soul."

-George W Bush

ANNTELNAES

PUTIN'S SOUL, 11/1/03
Courtesy of Tribune Media Services

President Bush declared, "I looked the man in the eye. I was able to get a sense of his soul," after meeting with Russia's leader Vladimir Putin on June 16, 2001. A friendship between the two men persisted, even when their opinions on serious policy issues diverged. Putin imprisoned and removed from office political opponents. In November 2003, Grigory Yavlinsky, head of a liberal opposition party, recollected Putin's 2000 pledge to "eradicate oligarchs as a class," and labeled Russia's current government as "capitalism with a Stalinist face"—reflected in this cartoon by the communist hammer-and-sickle gleam in Putin's eyes.

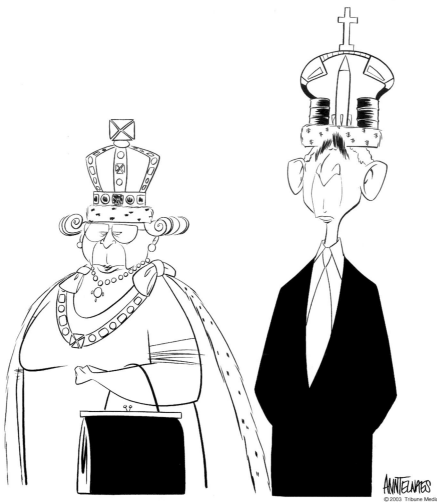

QUEEN ELIZABETH AND KING GEORGE, 11/19/03
Courtesy of Tribune Media Services

President Bush and his wife, Laura, arrived in England on November 18, 2003, as official guests of Queen Elizabeth II; their visit was filled with ceremonial occasions, including an opulent royal banquet at Buckingham Palace on November 19. Bush used the trip to defend his antiterrorism policies, including his highly controversial invasion of Iraq. Many Brits were upset by Bush's presence and his apparent closeness with the royal family and with Prime Minister Tony Blair. Demonstrations protested his military policies, symbolized by the missile in the crown he wears in this cartoon, which also alludes to his authoritarian attitude.

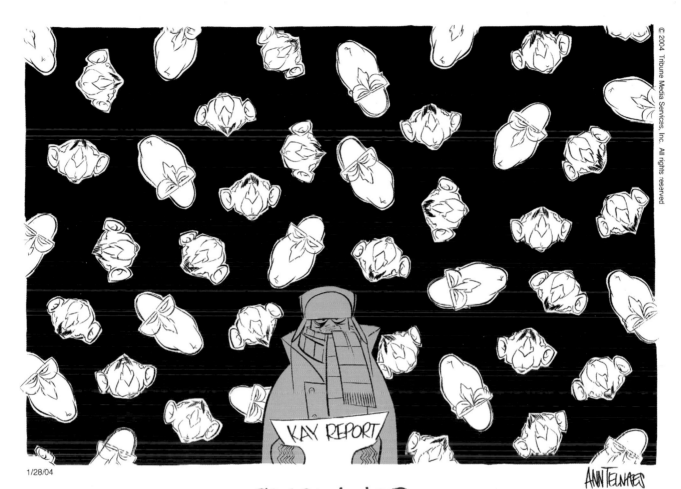

1/28/04

ANN TELNAES

SNOW JOB

SNOW JOB, 1/28/04
Courtesy of Tribune Media Services

After a nine-month search for weapons of mass destruction in Iraq, David Kay, retired chief UN weapons inspector, declared on television, "Clearly, the intelligence that we went to war on was inaccurate." On January 27, 2004, President George Bush responded that he was confident in his decision to attack Iraq. "There is no doubt in my mind the world is a better place without Saddam Hussein," Bush said. "The world is safer and the people of Iraq are free." Telnaes' cartoon shows the faces of Bush and Vice President Dick Cheney snowing down on a man reading Kay's report.

From your Admirers in the Taliban and in Kentucky

Watergate Florist

Congratulations card from colleague Joel Pett of the Lexington Herald-Leader.

WESTERN UNION | TELEGRAM

Official **TELEGRAM**

...WARD KLIMENTE
2950 BROADWAY
NEW YORK NY 10027

093396000030 04/16/01 TGM1 - TGMA
EM14959

0110609992946992
MS ANN TELNAES
WASHINGTON DC

YOU WERE AWARDED PULITZER PRIZE FOR EDITORIAL CARTOONING TODAY.
CONGRATULATIONS.

 GEORGE RUPP, PRESIDENT, COLUMBIA UNIVERSITY

MGMCOMP 15:14 EST

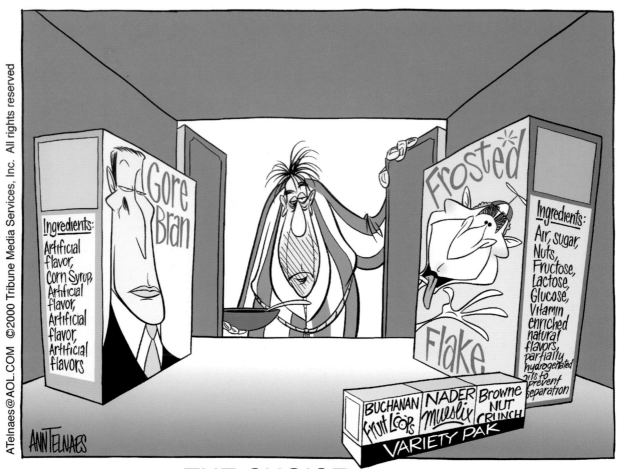

THE CHOICE

THE CHOICE, 10/31/00
Courtesy of Tribune Media Services

This cartoon likens choosing among the presidential candidates for the 2000 election to making a choice from standard, boring breakfast cereals. "I remember reading a story about how Americans were not that excited about the election," says Telnaes. "I thought, a perfect image is to have the American in the morning looking awful, not shaved, deciding which ridiculous cereal to eat. We've got Gore Bran, with artificial ingredients for flavor, and then we have Bush, who, at the time, was thought to be quite a lightweight. I had him as Frosted Flake."

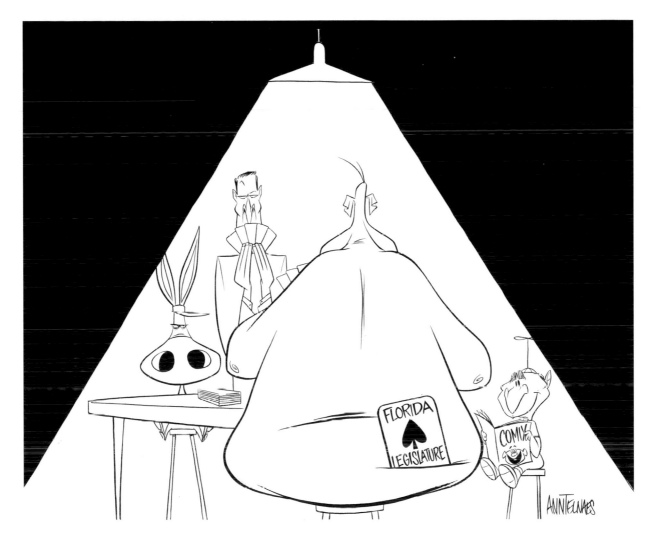

FLORIDA LEGISLATURE, 12/7/00
Courtesy of Tribune Media Services

Democratic candidate Al Gore's lawyers made a final effort to win the 2000 presidential election when they filed an appeal with the Florida State Supreme Court to agree to count 14,000 disputed ballots. The Republican-dominated Florida Legislature prepared to convene a special session for December 8 to appoint a group of electors who would support George W. Bush. Bush's brother Jeb was Florida's governor. "If the Supreme Court hadn't made the decision, then the Florida legislature would have decided whether or not the governor's brother was going to become president," says Telnaes. "This cartoon is about that ace in the GOP's pocket."

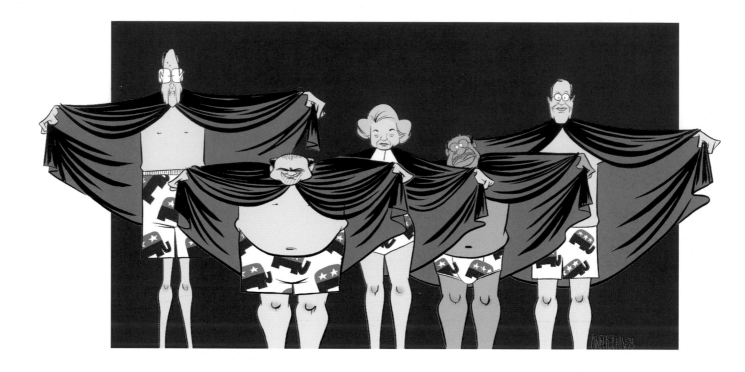

THE BUSH DECISION, 12/13/00

On December 12, 2000, the Supreme Court voted 5-4 to terminate the recount of disputed ballots cast in Florida in the presidential election of 2000. By overturning the Florida Supreme Court's earlier order for the recount to take place, the Supreme Court effectively handed the presidential election to George W. Bush. The five members of the majority depicted in this cartoon were Chief Justice William H. Rehnquist and Justices Antonin Scalia, Sandra Day O'Connor, Clarence Thomas, and Anthony M. Kennedy. They are all wearing "little Republican elephants on their underwear," says Telnaes.

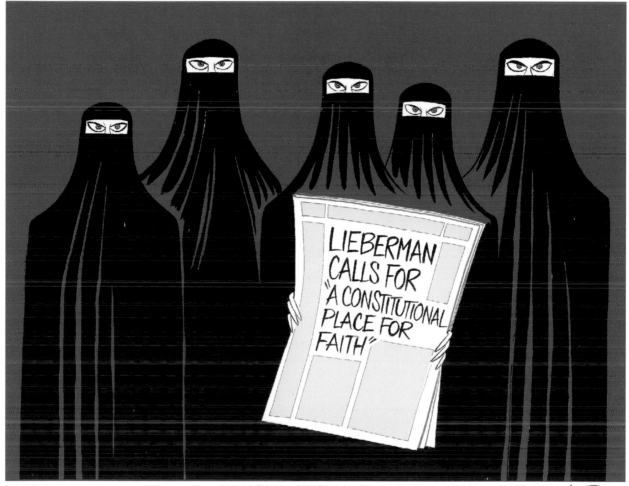

8/29/00 ©2000 Dist. by Los Angeles Times Syndicate ATelnaes@AOL.COM

LIEBERMAN CALLS FOR "A CONSTITUTIONAL PLACE FOR FAITH," 8/29/00
Courtesy of Tribune Media Services

While campaigning and speaking to groups of African Americans and Arab Americans in Detroit and the Midwest on August 28, 2000, Joseph Lieberman, vice presidential candidate and the first Jewish person to run on a national party's presidential ticket, stated, "I say there must be and can be a constitutional place for faith in our public life." Telnaes' cartoon reminds us of what happened when faith dictated public and private life under the Taliban regime in Afghanistan.

HAPPILY EVER AFTER?

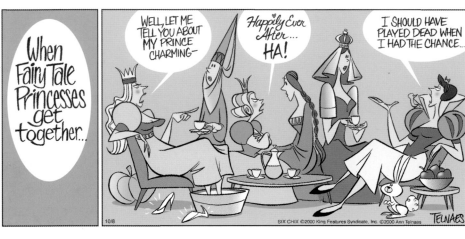

WHEN FAIRY TALE PRINCESSES GET TOGETHER . . ., *Six Chix,* 10/8/00
Courtesy of King Features Syndicate

Telnaes likes using fairy tales in the *Six Chix* comic strip because, as she says, they "are inherently sexist and have great potential for cartoons." In this cartoon, a group of fairy-tale princesses gathers to commiserate and exchange frustrations about how their relationships really turned out. Cinderella, whose glass slippers sit by the tub where she soaks her feet, has reservations about Prince Charming, and Snow White, next to a bowl of presumably unpoisoned apples, also expresses regrets.

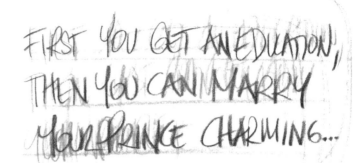

"First you get an education, then you can marry your Prince Charming," 11/3/03
Courtesy of King Features Syndicate

In this updated version of traditional fairy tales—whether Cinderella, Snow White, or Sleeping Beauty—a young princess listens reluctantly as she is admonished not to rely solely on romantic love for happiness and fulfillment. Modern-day heroines should be ready to rely on themselves.

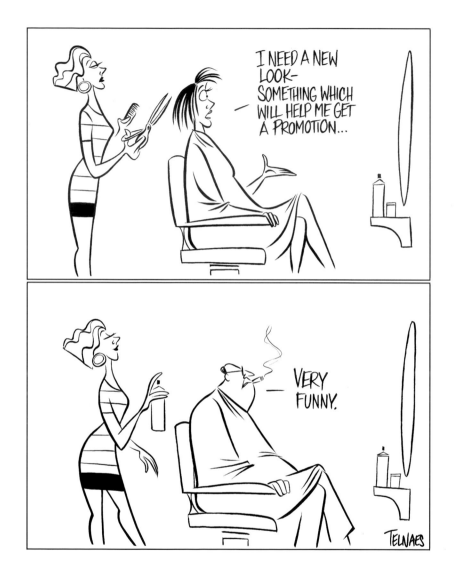

PROMOTION MAKEOVER, *Six Chix*, 9/12/99
Courtesy of King Features Syndicate

Telnaes pokes fun at women's expectations that beauty makeovers will significantly improve their chances for success in this humorous perspective on the beautician's role in women's lives. At the same time, it comments on the challenges that women encounter as they try to advance in the workplace, where being a man counts for more than a new hairstyle.

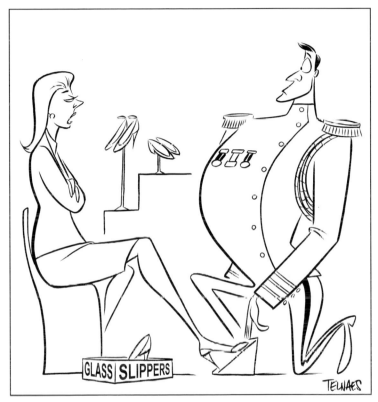

"That's great. Now may I see some comfortable shoes
I can wear to work?"

CINDERELLA'S SLIPPERS, *Six Chix,* 9/12/99
Courtesy of King Features Syndicate

In traditional versions of the Cinderella fairy tale, Cinderella proves her identity by fitting into the glass slipper that she lost at the ball, marries the Prince, and lives happily ever after. Today's skeptical Cinderella seeks more than glass slippers from a startled Prince—she wants a job and practical footwear that meet her abilities and needs rather than serve as a symbol of her fragile beauty.

"FIX YOUR OWN POWER BREAKFAST," *Six Chix*, 3/8/01
Courtesy of King Features Syndicate

This comic strip mocks and challenges the notion that today's women will willingly perpetuate traditional female roles, symbolized by the job of making the morning coffee. It also plays on the idea that everything from exercise to diet to meditation can bestow power on those who are ready to take it.

PERSONAL VICE AREA, *Six Chix,* 1/23/03
Courtesy of King Features Syndicate

Telnaes captures the array of temptations that women confront every day—to drink coffees and martinis, to buy too many pairs of shoes, to smoke, to eat too much—guilty pleasures that also contribute to overconsumption in American society. She also suggests that with smoking banned from many public places, banning other vices may soon follow.

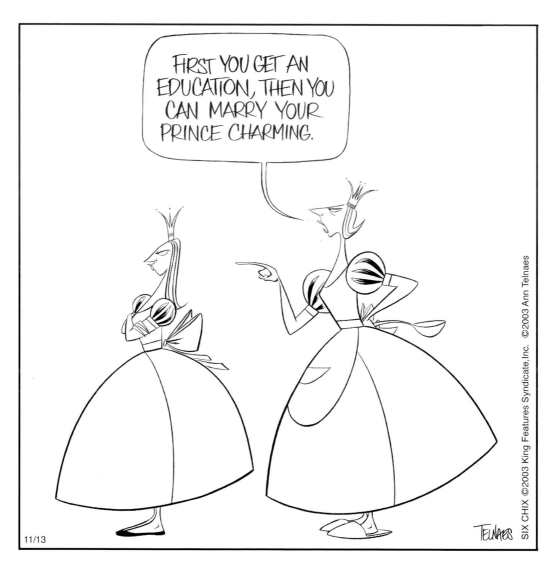

"First you get an education, then you can marry your Prince Charming," *Six Chix,* 11/13/03
Courtesy of King Features Syndicate

In this updated version of traditional fairy tales—whether Cinderella, Snow White, or Sleeping Beauty—a young princess listens reluctantly as she is admonished not to rely solely on romantic love for happiness and fulfillment. Modern-day heroines should be ready to rely on themselves.

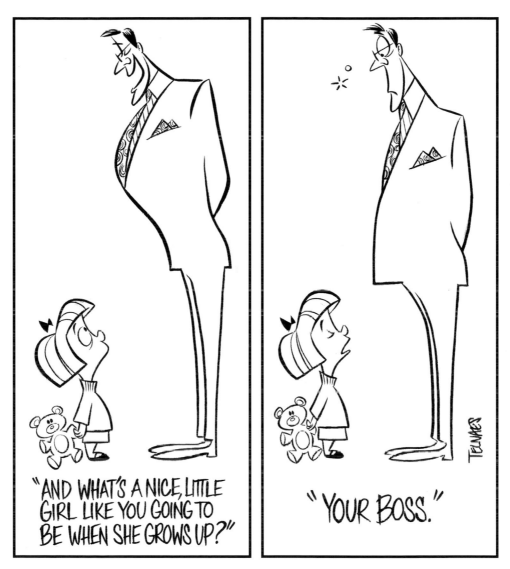

"AND WHAT'S A NICE, LITTLE GIRL LIKE YOU GOING TO BE WHEN SHE GROWS UP?" "YOUR BOSS." *Six Chix*, 9/10/99
Courtesy of King Features Syndicate

The use of a little girl in this early cartoon for *Six Chix* lends a humorous edge to a topic that continues to be highly charged today—women with ambition. Although the women's movement of the 1960s and 1970s made gains in rights and status, the changing and changed roles of women continue to be debated by both men and women.

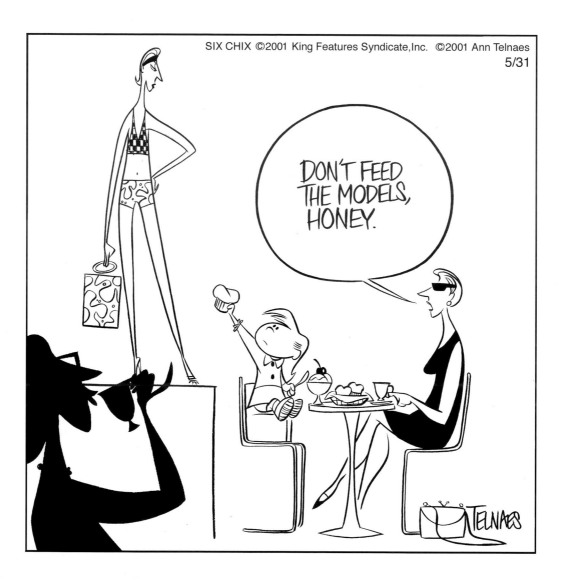

"Don't feed the models, honey," *Six Chix,* 5/31/01
Courtesy of King Features Syndicate

Models appear as a separate species of human in this cartoon that stresses the ultrathin body image exalted by advertising and popular culture. Thin is considered ideal for women, but obsession with weight can lead to eating disorders like anorexia and bulimia, as this serious underside of Telnaes' humorous commentary reveals.

Katharine Hepburn
1907 - 2003

For Women's eNews 7/2/03 ANNTELNAES

KATHARINE HEPBURN, 1907–2003, 7/2/03
Courtesy of Women's eNews

Katharine Hepburn died on June 29, 2003. Telnaes' caricature of the actress captures her incomparable spirit of elegance, indepen-dence, and strength.

INDEX OF CARTOONS

Page numbers are indicated in **boldface**.

All cartoons and drawings © Ann Telnaes.

Those images with digital ID numbers (i.e. LC-DIG-ppmsca-12345) are in the collection of the Prints and Photographs Division, Library of Congress. Reproduction of works in this book is restricted by copyright law. For permission to reproduce images by Ann Telnaes, please contact the appropriate rights holders identified below.